WILLIE DOHERTY

False Memory

Carolyn Christov-Bakargiev
and Caoimhín Mac Giolla Léith

MERRELL

Irish Museum of Modern Art

MERRELL

First published 2002 by
Merrell Publishers Limited
42 Southwark Street
London SE1 1UN
www.merrellpublishers.com

in association with

Irish Museum of Modern Art
Royal Hospital
Military Road
Kilmainham
Dublin 8
www.modernart.ie

Published on the occasion of the exhibition *Willie Doherty: False Memory*
organized by the Irish Museum of Modern Art, Dublin
31 October 2002 – 2 March 2003

Distributed in the US by Rizzoli International Publications, Inc. through
St Martin's Press, 175 Fifth Avenue, New York, New York 10010

British Library Cataloguing-in-Publication Data:
Christov-Bakargiev, Carolyn
Willie Doherty : false memory
1.Doherty, Willie, 1959– 2.Photography, Artistic – Ireland
3.Video art – Ireland 4.Installations (Art) – Ireland
I.Title II.Mac Giolla Léith, Caoimhín
III.Doherty, Willie, 1959– IV.Irish Museum of Modern Art
709.2

ISBN 1 85894 179 2

Produced by Merrell Publishers Limited
Designed by Karen Wilks
Edited by Brenda McParland, IMMA, and Iain Ross
Compiled by Karen Sweeney, Alexa Coyne and Rachael Thomas, IMMA
Printed and bound in Italy

Front and back cover: *Re-Run*, 2002 (detail, pp. 88–91)
Frontispiece: *True Nature*, 1999 (detail, pp. 66–73)
Page 2: *Retraces*, 2002 (detail, pp. 84–87)
Pages 4–5: *Sometimes I Imagine it's My Turn*, 1998 (detail, pp. 60–61)
Page 8: *Same Old Story*, 1997 (detail, pp. 54–57)
Page 10: *Sometimes I Imagine it's My Turn*, 1998 (detail, pp. 60–61)
Page 18: *Re-Run*, 2002 (detail, pp. 88–91)
Pages 26–27: *Sometimes I Imagine it's My Turn*, 1998 (detail, pp. 60–61)
Pages 154–55: *Re-Run*, 2002 (detail, pp. 88–91)

Pages 92–93: *Wasteground*, 1992, black-and-white photograph,
122 × 183 cm (48 × 72 in.)

CONTENTS

FOREWORD

This monograph marks the first substantial exhibition of Willie Doherty's work, entitled *False Memory*, at the Irish Museum of Modern Art, Dublin. Willie Doherty is one of Ireland's leading artists, with a long-established international reputation, and it is therefore timely that such a significant exhibition and publication should take place. Since 1980 Doherty has exhibited in over forty solo exhibitions, numerous group exhibitions and a number of public art projects worldwide. Short-listed for the Turner Prize in 1994, he has had solo exhibitions in venues such as the Tate Gallery, Liverpool; the Ormeau Baths Gallery, Belfast; Matt's Gallery, London; the Musée d'Art Moderne de la Ville de Paris; the Art Gallery of Ontario; and the Renaissance Society, Chicago. In 2000 Doherty was awarded a DAAD Berlin scholarship and in 2002 represented Great Britain at the São Paulo Bienal, where a new work entitled *Re-Run* was premièred.

The book and accompanying exhibition explore ideas of memory and place, including work from throughout Doherty's career to date (1985–2002). Much of Doherty's artistic output has emanated from, and is closely linked to, his native city of Derry. The exhibition and book survey an extensive body of work, in photography and video, that demonstrates developmental shifts as well as recurring concerns within the artist's practice. Although most of his works refer in some way to the physical and political landscape of the city of Derry and its environs, there is also a measured detachment present that resonates beyond Ireland, giving it universal appeal and international significance.

False Memory, book and exhibition, involved the collaboration and co-operation of several people. I should like to thank Willie Doherty for his inspiration and involvement as a thinking partner in the realization of the project. My sincere thanks also to Robin Klassnik, Matt's Gallery, London; Carolyn Alexander, Alexander and Bonin, New York; Kerlin Gallery, Dublin; and the staff of each of these galleries, whose contributions have been invaluable from the outset. I should also like to acknowledge the generous support of the equipment for the exhibition by the British Council, initiated by Richard Riley, curator, British Council, London. Finally, my thanks to the private collectors and public institutions who so kindly lent their works to the exhibition.

Brenda McParland
Senior Curator: Head of Exhibitions
Irish Museum of Modern Art, Dublin

A FALLIBLE GAZE: THE ART OF WILLIE DOHERTY
Carolyn Christov-Bakargiev

Let us go back to a possible starting-point. It is never redundant to try to recall certain things. On 30 January 1972 thirteen people were killed by British troops during a demonstration in Derry, Ireland. It was then that the Irish Question – typically seen as a conflict between the Nationalists of the Catholic community and the Unionists of the Protestant community – became world news. The events of that day, known as 'Bloody Sunday', became seminal events for many people living through the Troubles, as Willie Doherty was, and even for those growing up in Northern Ireland today they have become mythical. Doherty's art could be said to have emerged, ten years later, from this traumatic 'original' or 'first' tragedy.

A year earlier, in 1971, Susan Sontag published in New York some of the essays that were to become the seminal book *On Photography*.[1] She described how:

In teaching us a new visual code, photographs alter and enlarge our notions of what is worth looking at and what we have a right to observe To photograph is to appropriate the thing photographed. It means putting oneself into a certain relation to the world that feels like knowledge – and therefore like power Photographs furnish evidence A photograph passes for incontrovertible proof that a given thing happened. The picture may distort; but there is always a presumption that something exists, or did exist, which is like what's in the picture In deciding how a picture should look, in preferring one exposure to another, photographers are always imposing standards on their subject.[2]

She described how having an experience ultimately becomes identical with taking a photograph of it, in our Post-modern consumer culture in which everything seems to exist only in order to end up in a photograph, and she concluded with a hope for critical thought and practice in the future:

Photography implies that we know about the world if we accept it as the camera records it. But this is the opposite of understanding, which starts from *not* accepting the world as it looks. All possibility of understanding is rooted in the ability to say no If there can be a better way for the real world to include the one of images, it will require an ecology not only of real things but of images as well.[3]

Throughout the past twenty years, Willie Doherty has been exploring the possibilities of such an ecology of images. His black-and-white photo-text works of the 1980s, his audio/slide projections of the early 1990s, his colour Cibachromes of the 1990s, the video installations he has made since then, as well as the photographs he has always taken, all attempt to address areas of the mind and of our daily surroundings in which evidence is proof only of a lack of knowledge (and power), and of doubt. By *evidently* using cinematic tropes[4] in an exaggerated manner, and by mimicking the omniscient documentary commentator, he does not intend to shy away from the world, but rather to enhance our awareness of the constructed nature of images, even the most documentary, so as to formulate a new kind of individual perspective or agency, able to shape and modify consciousness by attributing value and importance to what could be defined a *fallible* gaze.

Doherty thus points to what photography cannot say, what it cannot get at, what is inaccessible to the camera (and to us), what *dis*-empowers us. For Doherty "photography continues to point to aspects of the 'real' subject, whatever that subject is (a landscape, a person, *etc.*), but there is a whole layer of that subject's activity that photography just can't represent or get to adequately. Photography is thus an inadequate tool, inadequate to the role it has been assigned by society".[5]

This impulse emerges from Doherty's awareness of and concern with photographic apparatus in our society, with surveillance systems such as helicopters hovering over cities with cameras, or video masts scrutinizing the city. As an intellectual, and as an artist in particular – someone supposed to be

constructing visual culture – Doherty has always been aware of his participation and possible implication in the violent nature of photography and video, and he wants, pragmatically and programmatically, to create a separate identity from this. His photographs and his audio/video work are partial, incomplete: they are disrupted, opaque visions, suggesting a 'disabled' gaze, ecologically (and ethically) frozen or interrupted at the borders of privacy. Doherty thus posits a form of 'weak subjectivity': his gaze does not penetrate, nor does it go beyond a surface. It is an act of resistance that celebrates the failure of photography rather than its success, the blind spot rather than the omniscient gaze, the side of the road rather than the road, the uneventful rather than the grand act, doubt rather than certainty, silence rather than proclamation, inner speech rather than broadcast news.[6]

Doherty began making art at a time when a number of artists, such as Barbara Kruger, Jenny Holzer and Dara Birnbaum, were interested in feminism and the politics of representation. They furthered radical conceptual art by looking at television, posters and the news media in general, creating artworks that effectively subverted and critiqued the positions of power implicit in popular communication. In some ways, Doherty's early work resembles such art and emerges out of that context. What was already distinctive in his work, however, was the sense of there being a specific point of view, at every moment, even when that point of view shifted vertiginously from one picture to the next, sometimes merely because of the different connotations of the words overlaid on the picture (such as in the diptych *Protecting/Invading* [1987; p. 104]). In some early photographs, such as *The Walls* (1987; p. 100), he framed the images in such a way as to reproduce the colonial power structure already present in the city of Derry itself.

Although he continues to make individual photographs, Doherty's work has slowly become more spatialized and has expanded to incorporate different media and techniques. In the late 1980s Doherty was acutely aware of the ways in which the media, and the state through the media, were constructing – and isolating – the image of a 'stranger', a 'wild native', an 'unfathomable terrorist' in Northern Ireland, thus disseminating paranoia within society. The Media Broadcast Ban of 1988 had made it illegal for organizations such as Sinn Féin to have a voice on television or the radio. This is when Doherty began to create audio/slide installations, such as *Same Difference* (1990; pp. 28–33) and *They're All the Same* (1991; pp. 34–35), that gave a 'voice' back to the silenced. These works explore opposite views, often mimicking the dualistic and binary structure of conflict.[7] The use of voice-over begins with *They're All the Same*. This work tried to break open the mediated image of the terrorist. An official mug shot of an IRA suspect on the run is projected, while a disembodied voice is heard that could be the voice of the man we see. It is a divided inner voice, references to the motives for becoming a terrorist – allegiance to territory and landscape, the idea of nationhood and homeland – alternating with thoughts suggesting self-doubt, ruthlessness alternating with integrity, heroism with fear of an innately barbaric nature.

Shortly after these slide installations, and twenty years after the fact, Doherty began to work on *30th January 1972* (1993; pp. 36–37), a project that would shift his attention further towards exploring how identity is fractured and hybrid, and intimately intertwined with memory. This project was based on interviews he made in the area where Bloody Sunday had occurred. Doherty asked two questions – whether the person was an eyewitness to the events, and, if the answer was yes, what they had seen. If the answer was no, he asked them if they could describe photographic or televised images of Bloody Sunday.

Exploring memory processes became of primary importance to the artist, and he began to fracture the dualistic structure of his earlier work, opening up what he felt was a psychological and political

Protecting/Invading (diptych), 1987

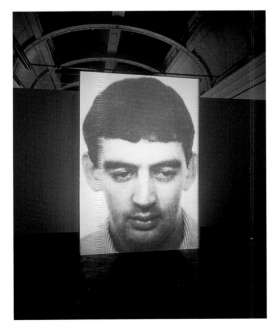

They're All the Same, 1991

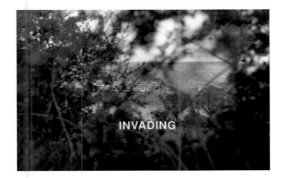

INVADING

stalemate. Doherty began to question the impact of the media on collective memory, how our memory of certain events becomes contaminated by our experience of them in a set of images created for another purpose. Aware of earlier artists working with video, such as Dan Graham, Bruce Nauman, Bill Viola and Gary Hill, Doherty also began to work with this medium. This shift of interest came from wanting to bring a temporal dimension into his art and to explore further techniques and references to cinema. His first video installation was *The Only Good One is a Dead One* (1993; pp. 38–39), made the same year as *30th January 1972*.

The Only Good One is a Dead One is an installation that comprises two videos projected simultaneously on walls at right angles to each other, so that the viewer can never see both at the same time. The voice-over is a monologue of a man who switches constantly from being a possible target of violence, a victim, to being a stalker, and assassin carrying out surveillance and closing in on his prey. The work suggests that there is no position for the innocent bystander, that everyone has a designated position from the perspective of the person who is killing. If you are in the wrong place at the wrong time, you become the designated victim. The positioning of the screens is therefore very important to Doherty in this and subsequent installations.

Doherty's background in sculpture may partly explain his acute awareness of space and how the space in which the work is viewed impacts on its meaning, and becomes part of it. But this symbolic positioning of the viewer in relation to the projection screens also recalls the experience of being in Derry. When in Derry, awareness of your position in relation to safety, control and surveillance is heightened. The old city centre, within the walls, is up on a hill, and traditionally represents the Unionists, while The Bogside, mainly a Catholic neighbourhood today – and the site of riots in the past, including Rossville Street, where Bloody Sunday occurred – lies in a dip below the walled city, as well as spreading on to the

hill opposite the bastions. This oppositional structure is a power relationship, expressed as a spatial relationship in the city itself, and it is repeated by Doherty in the spatial disposition of some of his early photo-text works, such as *Protecting/Invading*.

At the start of this essay, I described what might be called Doherty's fallible gaze, his saying 'no' to the power of photography, his ecology of images. Let us return to that now.

One of the recurring characteristics of the titles of Willie Doherty's works throughout the years has been to reference something in negative terms, something against a norm, outside a place or opposite to a rule. A use of prefixes that negate, such as 'un-' or 'dis-', appears in titles such as *Discarded Number Plate* (1996; p. 126), *Unreported Incident* (1995), *Disused Border Crossing* (1997), *Unapproved Road* (1992; p. 112) and *No Visible Signs* (1997; p. 133). *Out of Sight* (1997; p. 134) points to something in a location beyond what is visible. Some titles refer not to a place but to a time that is out of the camera's eye. *Abandoned Interior I, II* and *III* (1997; p. 136) for instance, is a location where events took place, but we who view the image are too late to interrupt or interact with them. Someone has abandoned, or left, the place.

A recent example of this is the series of photographs entitled *Extracts from a File* (2000; pp. 146–51), made in Berlin. These nocturnal photographs are mostly black, with very few architectural details – a window, a portion of a building, a passageway, a street-light – clearly visible and highly defined. The suite of sombre, contrasted black-and-white images was achieved by exposing the film with a short shutter speed of one-sixtieth or one-thirtieth of a second, and then over-developing the film so that only very bright areas of the image appeared, thus causing most of the picture to remain black.

Parallel to this inadequacy of the photographic medium, Doherty's locations are also useless,

unproductive spaces and situations. They are waste spaces. Doherty does not construct the spaces he shoots, as some contemporary photographers do. He positions the camera in places that would otherwise be inaccessible, places that are difficult to get to or unusual, and then offers these viewpoints to the audience. There are both romantic and anarchist impulses behind wanting to linger in these unproductive spaces, places you are not supposed to be in, places of transgression, ruins, places laden with traces and memories.

The Wrong Place (1996; pp. 48–51) is a video set in an old building. It is shot using a hand-held camera, and the viewer identifies with an absent figure holding the camera as it moves through the space. You hear the person's footsteps. The space seems to have been deserted a long time ago, yet cigarette butts on the floor, and other traces, indicate more recent use, evoking the idea of a temporary refuge. It is a place where you are not supposed to be, open to unauthorized use. This is a 'wrong' place, where we shift continuously between searching and hiding, pursuit and flight, seeing and being seen.

Alongside these physical locations – both indoors and outdoors – is an interior world explored by Doherty. What is the space of the mind you are not supposed to be in, a state of mind you should not indulge in? Among the many possibilities are fear, hysteria, terror. There are places that cannot be 'surveilled', and his art explores this transgression. False-memory syndromes, indulgence in reveries, and the oneiric mixing up of reality and fiction point to unproductive territories of the mind. People have memories of places they have never been to, owing to the cinema, which provides mediated experience. Doherty's works tap into that process. His art becomes part of the media that constructs these false memories.

Since the cease-fire of 1994, Doherty's art has been about trauma, and exploring the past. A more existential position has emerged. There is less sense of the urgency of events. Conflict exists in a more

subtle way. Recalling his fascination with blind spots, Doherty, when addressing memory, is interested in what is inaccurate, what is not remembered correctly. Over time, memory fades, people grow old and events seem to change. People try to remember a traumatic event, to arrive at the truth of what happened. There is a shared experience that slowly turns into collective memory. Some moments of emotion seem to be locked in stone, while the reality of the event feels completely lost and fictitious. We mix up what really happened and what we choose to remember, as well as mixing that up with other people's memories, television coverage, films, and so on. False-memory syndrome is common in the age of photography, in which we are often under the delusion of being able to control the past. Human memory as a process that is fallible thus becomes a topic for Doherty.

This process is related to the ways in which Doherty has dealt with the human figure. This has become more common in Doherty's work over the years, from making works where an 'absent' figure is present in the form of a specific viewpoint, identified with the eye of the camera, to works where inner speech is introduced as a way of breaking open simplistic figuration, to the introduction of hybrid, collective identities, to the presence of fleeting, mysterious and marginal characters in videos, and finally to the solitary, emblematic figure of recent work. These strands of work seem to begin at a certain point, and then develop in a parallel fashion, overlapping one another, so that no clear distinction of 'periods' of work can actually be made.

In the early photographs and slide works, Doherty dealt with the figure through its absence, by implication. There was an invisible presence, represented by the eye of the camera, an absent figure who was looking at us or whom we identified as being within us as we looked outwards, thus making us feel like invisible onlookers ourselves. He was denouncing the disrespectful way it was being used in the media. His own photographs were not to be like that: they were to avoid the violence of the

The Wrong Place, 199

No Smoke without Fire, 1994

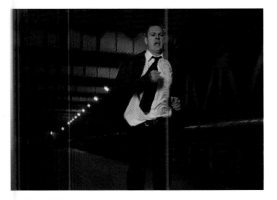

Re-Run, 2002

photograph. "I knew what it felt like to experience people coming to report on the Troubles, and taking pictures of me in the street."[8] Feeling disenfranchised himself, he avoided the scrutinizing gaze, avoided victimizing the subject, but offered the viewer a point of view that suggested the presence of the body, and of a figure, through its absence. Cinematic devices were more useful to Doherty than the tradition of photography, since film has been the most 'personal' of art forms in the last century, engaged as it is with point of view. This point of view, this absent figure, is a secret and intimate gaze, as if a person were concealed, looking through the foliage. There is discomfort, too, a sense of illicit, voyeuristic and insidious behaviour. What are you doing peering from a bush? Or looking from the ramparts on to the people below? The absent figure continues to feature in later works by Doherty, and is present in videos such as No Smoke without Fire (1994; pp. 42–43), in which the footsteps in the grass of the person carrying the camera can be heard, and in The Wrong Place, in which panting and sounds of running abound.

His critique of the stereotypical, mediated portrait of the 'Irish' brought Doherty to address a fractured self, riddled with self-doubt, in Same Difference, They're All the Same and The Only Good One is a Dead One. 30th January 1972 presents multiple selves, a choral identity made of projections and memories, mixed with media representations addressed again in True Nature (1999; pp. 66–73). This last work explores dislocation and the fantasies and projections of Irish-Americans who have never visited Ireland. It juxtaposes views of Chicago with snippets of these interviews and views of Ireland made after the interviews, attempting to depict some of the places described. There is a dreamy quality to the work, with long slow fades from one sequence into another and stories overlapping in a slightly chaotic manner.

Doherty's work shifts from the suggestion of presence through the camera's point of view to a represented figure, as seen in Factory (Reconstruction) (1995; p. 47). In this work an inexplicable character enters and exists in a destroyed factory interior, perhaps trying to make order in the rubble. He is an emblem of a state of mind, recalling characters of Samuel Beckett, carrying out inexplicable, repetitive actions in an existentialist atmosphere.

How it Was (2001; pp. 80–81) recalls The Wrong Place, but includes a voice-over and the presence of three ghost-like, weird figures. They are 'there' without being there. The work is set in a derelict garage, and the camera moves slowly, scrutinizing the spaces it moves through. What you see and what you cannot see – what you remember and what you do not remember – are the focal points. Shot in a dim light, much detail is lost; the work is about not remembering details. Similarly, the voice-over describes a fictional event that may have happened there. There is a contemplative mood, a sense of blurring as when memories fade; dream and reality overlap; it is like being underwater.

Just as Doherty's multi-screened video installations have become ever more complex over the years, so identity has been fractured through the inclusion of inner speech, the relationship between fiction and reality through memory, and the hybridization of subjectivity in collective consciousness. This hall of mirrors comes to an abrupt halt with Doherty's most recent video installation, Re-Run (2002; pp. 88–91), which features a man in a business suit running towards the camera on one screen, and away from the camera on another screen, in an obsessive thirty-second double loop with no sound. He is running at night over the covered bridge in Derry that crosses the River Foyle, a symbol of division and connection. Permanently located in the middle of the bridge, he never reaches a destination and is caught in a Sisyphean trap. This work apparently returns to the simpler dual structure of earlier photographs and slide projections that revolved around paranoia and conflict. No binary vision of the world emerges here, however, since the editing of the loops is made up of

a subtle montage of more than forty short sequences of different takes on the figure – wide shots, mid-shots and close-ups. This rapid montage sequence and the lights on the bridge – which on video appear red – heighten a sense of anxiety and emergency. While the area around the man is bathed in this red light, the man himself is not, and his shirt is extraordinarily white. This was achieved by lighting only the figure during filming. The experience is tight, direct, distilled and viscerally engaging, in some ways more Modernist in its existential, 'essentialized' nature than other, more fractured and Post-modernist works by Doherty. Doherty's experience of the mediated images of the attack on the World Trade Center, New York, in 2001 is one source for this work, which is not just about events in Derry. The scene could be anywhere, in any urban environment, and the covered bridge could cover subway tracks in many contemporary post-industrial cities. The figure is not a specific person, but Everyman; not an individual but an emblem, something more primary and archaic. The work is closer to Christian iconography than any other by Doherty to date.

Christianity and its iconography deal with trauma and catharsis. They are based around a story of deceit, betrayal, tragedy, sacrifice and, finally, possible salvation. The depiction of the suffering, death and final resurrection in this drama is central to Christian iconography. Essential to it, also, is the mystery of transubstantiation, the absent yet at the same time present body of Christ – something of a missing body of evidence.

Sometimes I Imagine it's My Turn (1998; pp. 60–61) is a video that joins the technique of the 'absent figure', who is holding the camera and walking through a country landscape, with the representation of another figure on the ground, perhaps a fantasy of one's own death. There is no voice-over here, just the sound of wind in trees and of an ominous helicopter overhead. This deposed, Christ-like figure is approached from a highly foreshortened perspective.

One of Willie Doherty's favourite paintings is the Italian Early Renaissance painter Andrea Mantegna's *The Dead Christ* (*c*. 1480–90). A deposed Christ is seen lying down, his head resting on a cushion, with two crying figures by his side. A unique perspective is achieved through extreme foreshortening, the painter positioning himself at the foot of the dead Christ. This positioning of the artist's gaze disrupts the traditional omniscient view from the front and accentuates the sense that there is a real person looking at the scene, a person that we, the viewers, can identify with. Such a strange viewpoint, a reversal of the normal perspective of Christ in religious paintings, allows for no sense of detached observation, no power over the scene, only an empathetic, compassionate, implicated gaze. As the cinema would, centuries later, Mantegna achieved a 'close-up' view that confronts the viewer and brings into play a psychological mood.

It is useful to look at Doherty's relationship with the history of art that deals with pain, suffering and social struggle, rather than interpreting his work in relation only to a specific contemporary social and political context. Similarly, it is useful to examine not only his appropriation of cinematic strategies, but also his relationship with earlier figurative painting, so influential on photography and cinema themselves.

Partly as a reaction to the utopian view of photography as something indexical proposed by conceptual and land artists in the 1960s and early 1970s, Post-modern photography had, since the late 1970s, underlined the constructed and artificial nature of experience. Doherty's enterprise, however, was different. Doherty mistrusts the photograph.[9] By focusing on the point of view and gaze of the artist/viewer, he thus repositioned a possible self in direct experience. Something really did happen on Bloody Sunday – thirteen people were killed by the army in the streets – and Doherty, a mere twelve years old, saw the traumatic events from the upstairs window of his parents' home. The twin towers of the World Trade Center really did fall in New York City on

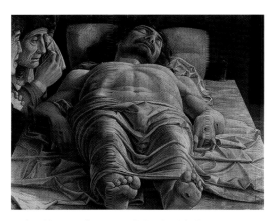

Andrea Mantegna (143?–1506), *The Dead Christ*, *c*. 1480–90, oil on canvas, Pinacoteca di Brera, Milan, Italy/Bridgeman Art Library

Sometimes I Imagine it's My Turn, 1998

11 September 2001. They did not tumble down only on television. Some people in New York that day thus experienced the need to negotiate between the mediated image on television that they, too, were viewing in real time, and the smell of burnt metal, bodies and plastic in the streets outside their windows, as in all war zones around the world. The idea that experience is completely mediated is a Post-modern fallacy, an illusion of power over experience, more a desire for freedom from the body through technology than a reality for most people in the world. There is always a certain texture of experience that the media cannot pick up on, the texture of what conflict feels like from within.

It is the encounter between individual, personal consciousness – the processes of perception, memory and knowledge – and the mediated image that interests Doherty. His art, specifically by addressing the fallibility of the photographic (and by extension filmic) image, is playing an important role, as his artworks slowly enter the public realm and participate in the effort to formulate collective memory. Therefore, Doherty has effectively laid the ground for an art that explores the relationship between personal experience and social reality, individuals and collectives, individual memory and collective memory. Fundamentally, this has meant looking at the documentary image. Today, a growing number of younger artists is pursuing this endeavour, and Doherty is no longer a solitary figure. Examples are many, from the re-enactment by Jeremy Deller (born 1966) of a miners' strike at the Orgreave coking plant in 1984 (*The Battle of Orgreave* [2001]), organized by Artangel as a performance and then filmed by Mike Figgis, to the 'documentary' videos of Anri Sala (born 1974), such as *Intervista – quelques mots pour le dire* (1997), which includes found documentary footage of his mother as a young woman being interviewed about politics in Albania in the 1970s and images of himself looking at the footage and commenting on it with his mother today, experiencing the gaps in memory, and history. Insofar as there is a continuous, on-going process,

a process of alertness, of searching for truth, of verification of evidence, and of awareness of the constant failure of this process, then subjectivity is alive and well, and consciousness is safe. Doherty has suggested a way to recover some sort of 'modern' self – an engaged self – through his pragmatic approach. It is a self that had just better keep on running, both away from and towards its goals, looking neither forwards nor backwards. As for Mantegna, grappling with representation at the birth of modernity, the question at stake, once again, is point of view.

1. Susan Sontag, *On Photography* [1977], London 1979.
2. *Ibid.*, pp. 3–6.
3. *Ibid.*, pp. 23, 180.
4. See Maité Lores's essay on this topic, 'The Streets Were Dark with Something More than Night: Film Noir Elements in the Work of Willie Doherty', in *Willie Doherty: Dark Stains*, exhib. cat., Koldo Mitxelena Kulturunea, Donostia-San Sebastián, 1999, pp. 110–16.
5. From conversations with the artist, 28 March 2002.
6. Jean Fisher, in 'Seeing Beyond the Pale: The Photographic Works of Willie Doherty', has already stated that "Doherty's blind spots, veils, and absences, the opacity of the view and its refusal to surrender its contents to the controlling gaze of the camera, reveal the inadequacy of the photograph. Here, contrary to the common belief in the photograph's pure transparency, something eludes the eye, exceeds the focus or frame of the image", *Willie Doherty: Unknown Depths*, exhib. cat., Cardiff, Glasgow and Derry, 1990, unpaginated.
7. In 1980, as a student, Doherty had already constructed a double-sided slide-projection installation with a cloth screen tied to the floor and to the ceiling. The ropes were held up by slide projectors on shelves on both sides of the cloth screen. The slides were of landscapes and of childhood memories.
8. *Op. cit.* note 5.
9. When Doherty was a student at art school in the early 1980s, Richard Long came to Derry to give a talk. He showed some slides and spoke about how the photograph stands in for a walk. For Doherty, one photograph could never be enough. He was attracted to the medium but also frustrated by it.

TROUBLED MEMORIES

Caoimhín Mac Giolla Léith

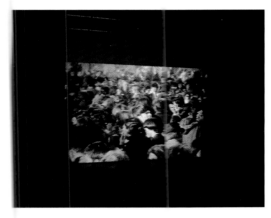

30th January 1972, 1993

Willie Doherty's *30th January 1972* (1993; pp. 36–37) refers to an infamous day in recent Irish and British history. The full story of 'Bloody Sunday' is still being contested at the time of writing, in the light of the hundreds of submissions being appraised by the Saville Inquiry, set up by Tony Blair's Labour Government in 1998 to reinvestigate the events of that day. On Bloody Sunday thirteen unarmed civilians were shot dead by British paratroopers on the streets of Derry during the course of a march against the British Government's policy of internment. Doherty's installation was made in 1993, twenty-one years after the events it recalls, and incorporates archival material in the form of a projected black-and-white 35 mm slide of assembled marchers, taken from television news coverage of the demonstration, as well as an extract from a live sound recording made during the fatal shootings. This material is juxtaposed with a similarly enlarged 35 mm colour slide of a dead-end alley, one of the sites where the shootings occurred, as well as edited samples from recorded interviews conducted on the streets of Derry in 1993. The interviewees were asked to recount their experience of the fateful day, if they happened to be present at the time. If not, they were encouraged to describe a photographic or televised image that somehow encapsulated the event for them. The interviewer's questions have been excised from the three audio tracks that feature in the final installation, all of which emanate simultaneously from different corners of the gallery space, thereby producing a dense aural palimpsest that it is impossible to comprehend all at once, just as it is impossible simultaneously to hold in view the two images, which are projected on to opposing sides of the end wall of a carefully constructed cul-de-sac installed within the gallery.[1]

The disjointed, multi-vocal testimony of *30th January 1972* includes the following two (non-adjacent) sentences:

The only image I have about Bloody Sunday is that the people were innocent ...

His companion's head exploded just like you'd see it on a film ...

The young man who provides the first of these two quotes sounds both passionate and a little bewildered. Bewildered, obviously, by the still underacknowledged injustice of the event he has been asked to address; but also somewhat confused as to the precise mechanism through which he has been invited to address that event. He has clearly been asked for an image that recalls Bloody Sunday. Yet he responds, rather, with a categorical statement of belief in the innocence of the dead. Asked for something quite particular and concrete, he offers an abstracted generalization in its stead. He rebuffs the attempt to elicit a memorable representation of a traumatic event in the history of his community in a manner that suggests an unconscious distrust of just such representations. The second speaker quoted has no such qualms. Yet the arresting image he proffers is not couched in the language of first-hand testimony (at least in the edited, and thus relatively decontextualized, form in which we encounter it). Rather, it describes something that apparently happened to someone else's 'companion'. It represents this event, moreover, at a further remove from observed actuality, in terms explicitly borrowed from popular cinema.

Both speakers have evident difficulty in providing an image adequate to the specifics of the tragedy that was Bloody Sunday. Their responses, however, exemplify two contrasting methods of dealing with the fundamental problem of representing a traumatic event. These we might term iconophobia and spectacularization respectively. In resisting the lure of the exemplary image in telling the story of Bloody Sunday the first speaker points the way towards what Richard Kearney has described, in a somewhat different context, as "narrative memory *without images*" or, alternatively, "remembrance without *representation*" (the emphasis is Kearney's).[2] Kearney has usefully summarized and addressed, from a distinctly Irish perspective, a number of

recent debates concerning the relationship between narrative, memory and trauma. The two most controversial of these debates, which relate to collective and individual memory respectively, are the problem of revisionist histories of the Holocaust and the question of so-called 'false-memory syndrome' in the area of childhood sexual abuse.

In discussing the first of these topics Kearney focuses on Claude Lanzmann's critique of Steven Spielberg's Oscar-winning *Schindler's List* as a fatally flawed attempt to represent in dramatized form the unrepresentable event of Auschwitz. By mobilizing many of the elements of conventional Hollywood melodrama – spectacular illustration, emotional participation, audience identification, dramatic catharsis and conclusive redemption or reconciliation (*i.e.* the precise affective complex invoked through our second Derry speaker's allusion to popular cinematic convention) – Spielberg, according to Lanzmann, traduces the Holocaust not just by spectacularizing it, or even by fictionalizing it, but by attempting to render it in images in the first place. As Lanzmann puts it: "Fiction is a transgression, I feel deeply that there is a problem of representation … . Images kill imagination." In contrast, Lanzmann's own attempt to address the Holocaust, in his eight-and-a-half-hour documentary film *Shoah*, draws scrupulously and extensively on the accounts of many real-life survivors, who speak not primarily for themselves but, in a notably 'depersonalizing' manner, on behalf of the absent and voiceless dead, their fractured testimonies bearing witness to the impossibility of ever adequately representing what really happened in Auschwitz.[3]

Of course, Lanzmann's argument rests largely on the status of the Holocaust as a *uniquely* unrepresentable event. (In this his renunciation of the image parallels Adorno's famous admonition that there can be no poetry after Auschwitz.) Yet his iconophobic critique of the cinematic spectacularization of a traumatic historical event, as opposed to the painstaking accumulation of documentary testimony, has

considerable bearing on the assessment of Willie Doherty's art in general, and of *30th January 1972* in particular. For Doherty, in effect, contrives to have it both ways. By presenting communal memory as an aggregate of individual 'memories', ranged in a deliberately non-hierarchical manner, *30th January 1972* suggests that this form of composite memory can accommodate, however uneasily, the opposing impulses to resist the power of the image and to capitulate to it. The question of the precise nature and status of the individual 'memories' from which collective memory may be thus constituted, however, is left tantalizingly open. For, as we have noted, *30th January 1972* includes, alongside the testimony of those who were present on the steets of Derry on Bloody Sunday, images and narratives that circulate among those who were not. More crucially, no clear distinction is made between these two categories. This is dangerous territory indeed, as a number of dispatches from what have been aptly termed "The Memory Wars" will readily attest.[4]

From the vantage point of a practising psychoanalyst, Christopher Bollas has described the psychoanalytical insistence on the priority of the *imagined* as opposed to the *happened*, as "understandable, if regrettable". Yet he expresses grave reservations concerning his profession's increasing neglect of what he terms "the facts of a patient's life" in favour of the more arcane world of psychic events, in that it has thereby effectively ceded the key area of sexual abuse to an alliance of "police, oracular therapies and victim support groups", all too obviously predisposed to the uncritical acceptance of reports of recovered memories.[5] His reservations are shared by other commentators who argue that in conferring on the relatively new category of 'recovered memory' a status comparable to that we have traditionally accorded to our ordinary, persistent memory (*i.e.* that which we have *always* remembered) we do serious injury to a fragile but indispensable faculty and "debase the coinage of memory altogether" (this final phrase is Walter Reich's). As Richard

How it Was, 2001

I Was There and I Have Doubts (The Pit), 2001

Kearney points out, the consequences of a general destabilization of the category of memory may range from the unjust punishment of suspected abusers, convicted on the basis of the dubious evidence of so-called recovery specialists, to the provision of undue publicity to negationist historians of the Holocaust.[6]

Yet, as Willie Doherty's work has always insisted, despite the ethical and juridical imperative, arising from the aforementioned considerations, to establish the truth-value of particular memories, absolute reality will continue to evade representation and the unmediated past remain inaccessible in the present. Thirty years after Bloody Sunday this is still the argument of one of Doherty's most recent works, a work that speaks, though in a more oblique manner, to the same events addressed in *30th January 1972*. *How it Was* (2001; pp. 80–81) is an installation consisting of two synchronized widescreen video sequences projected simultaneously on to two large, free-standing screens. Both of these screens show footage of the gloomy interior of a large garage, clearly once dedicated to automobile repair, but now bereft of vehicles. Shot from various angles, and various degrees of proximity to the garage's sundry fittings and contents, in a choreography of camera movement that makes emphatic use of the slow pan, the footage gradually reveals three shadowy figures clad in blue mechanic's overalls, one woman and two men, who move slowly about the space. They are filmed largely from behind or above. Sometimes an arm is cropped at the elbow, or walking feet are cropped at ankle level. We never see their faces clearly. Their movements are purposeful but obscure. They never meet or interact or even share the same shot, so that we are invited to conclude that they may never have been in this building at the same time. A soundtrack featuring three voices, again one female and two male, which we may tentatively assign to these three isolated characters, plays from four separate speakers situated in the four corners of the darkened gallery space. Gradually it becomes apparent that the same restricted set of short phrases is being parcelled out and repeated by all

three voices. It also becomes apparent that the same set of scenes is being enacted by each of the three figures. No attempt is made, however, to co-ordinate sound and image, the sequencing in each case being different and seemingly arbitrary. We are free to walk around the two double-sided screens, which are set at some distance apart. That is to say that we are left to our own hermeneutic devices in a vain attempt to discern some overarching pattern or organizing principle that would allow us satisfactorily to marry voice to player to action, thereby affording us the consolation of making conclusive sense of an otherwise inscrutable scenario.

How it Was, which was first shown at the Ormeau Baths Gallery in Belfast in 2001, was made at the height of public interest in the proceedings of the Saville Inquiry. Even more than *30th January 1972* it highlights the problem of constructing an authoritative account of a complex event from the competing testimonies of various interested parties. Its soundtrack repeatedly underscores the difficulty of such a task, as the three disembodied voices struggle to bear truthful witness to an indeterminate event in a dim and distant past: "It all happened so long ago; it's like a different world"; "The light plays tricks at that time of the day"; "Everything is changed"; "I couldn't really see; I mean, that light's not great." At times the commentary seems to be keyed, however disjointedly, to a forensic examination of the specific scenario we are watching: "There was a hammer on the wall"; "His left hand was obscured; you couldn't see anything in the drawer"; "There was a TV set in the small office. I'm not sure if it was on." At times, however, it veers towards a more generic form of testimony that might equally relate to the Bloody Sunday inquiry: "By the late afternoon everything was over"; "I did what I could under the circumstances"; "There was no going back to check." The one unifying factor is a rueful and hesitant tone that pervades the entire commentary, a tone epitomized in the phrase *I Was There and I Have Doubts*, which also provides the title for a series

of large black-and-white photographs (2001; pp. 82–83) of the same garage interior that were originally exhibited in tandem with *How it Was*.

In his essay for the exhibition catalogue accompanying *How it Was* (2001) Daniel Jewesbury commends this particular artwork for counterposing "partiality and failure – constructive, critical failure – against closure and its authority".[7] The latter he finds exemplified, in contrasting ways, by the Saville Inquiry, on one hand, and Jimmy McGovern's fictionalized TV docudrama *Bloody Sunday*, on the other. In Jewesbury's view the disparate attempts by Saville and McGovern to tie up once and for all the irredeemably tangled threads of the narrative that is Bloody Sunday must inevitably result in either the false consolation of the (always prematurely) closed case or the artful blandishments of neatly packaged fiction. Jewesbury is at pains to anticipate and disarm the objection that the only alternative to what he presents as a hopeless search for absolute truth is an equally hopeless and debilitating relativism. Defending Doherty's approach against the criticism of those who would fault it for its occlusion of the material nature of political struggle and its disempowering insistence on a potentially endless deferral of meaning, Jewesbury cogently notes that an "assertion of *indeterminacy* is not the same as a *denial of meaning*".[8]

This insistence on indeterminacy has been a hallmark of Doherty's work from its very beginnings, as has his implicit advocacy of constant critical self-reflection in the matter of constructing and construing both images and narratives. Ulrich Loock has discussed the disjuncture between text and image in Doherty's early photographic work in terms of the strategic rupture in calligraphic unity between appearance and concept famously exploited by René Magritte and subsequently elucidated by Michel Foucault in his essay 'Ceci n'est pas une pipe'.[9] To take an early work as an example, *The Walls* (1987; p. 100) presents us with a panoramic view of Derry's Bogside from a vantage point immediately inside the

city's historic walls. Sandwiched between a thin band of pale, cloudy sky that stretches across the top of the picture plane, and a thin band of dark, grimy brickwork that stretches across the bottom, is a third narrow band of stepped terraces that houses part of the city's Catholic population. The inscription overlaying this middle section reads ALWAYS/WITHOUT in green lettering, a colour emblematic of Nationalism. At the bottom of the lower band, in blue lettering traditionally connoting Unionism, are the words WITHIN/FOREVER. Between these two inscriptions, in a larger font and in white lettering, we read two words: THE WALLS. As well as providing the work's main title, these two words constitute the obvious visual focus of the work when viewed from the middle distance. (From any further distance, and also in certain reproductions, the other legends become less legible, the 'Nationalist' inscription, especially, becoming almost invisible.) THE WALLS as a sign is thus both self-evident, in its function as tautological title, and riven to the core. To the Nationalist population the Derry city walls signify exclusion and deprivation (both meanings of the preposition 'WITHOUT'); whereas to the Unionist population they signify security and the preservation of a long-established order. In a comparable fashion, the two-part photo-text work *Stone upon Stone* (1986; pp. 98–99) draws a mordant comment on profound cultural difference from the juxtaposition of two seemingly generic views of a riverbank. These two photographs were apparently originally designed to be exhibited one opposite the other in a narrow, corridor-like space in such a way that the viewer cannot view both simultaneously in their entirety (a characteristic Doherty strategy also employed, as noted earlier, in *30th January 1972*).[10] While both photographs bear the overlaid inscription of the work's title, STONE UPON STONE, this is accompanied in one of them by the Republican slogan TIOCFAIDH ÁR LÁ ('Our day will come') and the designation, in green lettering, THE WEST BANK OF THE RIVER FOYLE, which is where the bulk of Derry's Nationalist community lives.

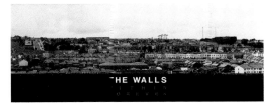

The Walls, 1987

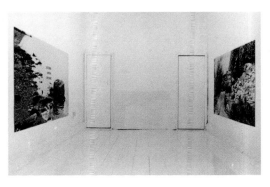

Stone upon Stone, 1986

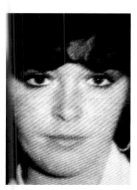

Same Difference, 1990

The Only Good One is a Dead One, 1993

Extracts from a File, 2000

The other photograph features, in blue lettering, the Loyalist slogan THIS WE WILL MAINTAIN and the words THE EAST BANK OF THE RIVER FOYLE, which is home to most of Derry's Loyalist population. In both of these works, and in Doherty's work in general, as Jean Fisher noted as early as 1990, "representation is a matter of *positioning*: the camera in relation to the object, the text in relation to the image, the viewer in relation to the physicality of the photographic installation".[11]

In many of Doherty's subsequent works throughout the 1990s this structural disunity between text and image is, as Ulrich Loock points out, reconfigured into the relationship between video and voice. This characteristic stratagem, whereby the contradictions at the heart of conventional signs, both visual and verbal, are revealed, I have discussed elsewhere in terms of Mikhail Bakhtin's concept of "intentional hybridisation". Bakhtin defines this radically contestatory, anti-authoritative activity as a particular form of dual articulation in which "two points of view are not mixed, but set against each other dialogically"; and Robert Young has more recently described it as "a politicized setting of cultural differences against each other".[12] Two early installations by Doherty, in particular, exemplify this approach and reveal how a debased use of language, tending towards cliché, can effectively contextualize the same image in markedly opposing ways. In *Same Difference* (1990; pp. 28–33) an image of the face of Donna Maguire, photographed from a television news broadcast following her arrest by the Dutch authorities as a suspected IRA terrorist is projected on to two diagonally opposite walls in a darkened room. Two contrasting sequences of words are projected on to each of the two identical faces. One of these is largely made up of pejorative terms gleaned from the anti-Nationalist popular press, (MURDERER … , PITILESS … , MURDERER … , MISGUIDED … , MURDERER … , EVIL …), while the other favours terms of pro-Republican approbation (VOLUNTEER … , DEFIANT … , VOLUNTEER … ,

HONOURABLE … , VOLUNTEER … , COMMITTED …). In *They're All the Same* (1991; pp. 34–35) a projected newspaper photo of another IRA suspect, Nessan Quinlivan, is accompanied by an audio monologue that offers a similarly contradictory characterization, couched this time in the first person: "I'm decent and truthful. It's in my bones … I am essentially evil … I am ruthless and cruel … I am proud and dedicated."

This strategic deployment of dual articulation in Doherty's work, which also characterizes, for instance, *The Only Good One is a Dead One* (1993; pp. 38–39), a two-screen installation with accompanying voice-over in which a monologue spoken by the same actor switches unnervingly between the rôles of assassin and potential target, has gradually given way to the more complex, multi-vocal, multi-perspectival orchestrations initially heralded by *30th January 1972*. At the same time the evolution of this body of work through the 1990s has been marked by a movement, or rather a series of movements, from the specific to the generic.[13] We may note the contrast, for example, between a work such as *The Walls* and *Extracts from a File* (2000; pp. 146–51), a set of forty small-scale, black-and-white photographs of night-time Berlin that Doherty shot during a year-long residency there. *Extracts from a File* was the first substantial body of work produced by Doherty that did not refer more or less directly to the lived experience of his native Northern Ireland and the ways in which daily life there (not to mention death) has been represented to a wider world. (Even his 1999 installation *True Nature* [pp. 66–73], produced and premièred in Chicago, interrogated the diasporic images of a romanticized native land concocted by second- and third-generation Irish-Americans who had never visited it.)

Doherty's Berlin is a maze of shadowy side streets and subways, dimly lit apartments and office blocks, ominous security grills, bars and railings, and flights of steps leading who knows where. It is also a Berlin

entirely devoid of people. Hung at irregular heights and in groups of five, the segmented, serpentine line of photographs, when installed *in toto* in a gallery, snakes around the walls and invites a reading in terms of an elusive, episodic narrative. Yet the lack of recognizable landmarks or co-ordinates, as well as the absence of *dramatis personae*, consistently frustrate any such reading. The work's collective title further emphasizes the incomplete nature of the 'evidence' presented and the futility of attempting to construct a comprehensive narrative from such fragmentary and fugitive material. The notional subject of this imaginary file remains absent and obscure. By summoning the spectre of the former East Germany's notorious Stasi files, *Extracts from a File* provides a crucial link with Doherty's previous reflections on the dispiriting effect of intrusive surveillance and oppressive security on his own community. Doherty's large-scale, colour photographs of Northern Ireland are ominous and unsettling largely because of their formal echoes of media depictions of sectarian crime scenes and the uncovered paraphernalia of paramilitary activity. The Berlin imagery is refracted more obviously through the cinematic portrayal of cloak-and-dagger espionage in the gloomily romantic cities of post-war Central Europe. Away from home, Doherty's concern seems less a matter of revealing the prejudices of television and tabloid journalism than of revelling in the conventions of cold-war *film noir*. Yet the intent remains serious and the strategy consistent, *i.e.* to call into question the ontological status of such categories as truth and fiction, actuality and preconception, substance and style, by constantly blurring the boundaries between them.[14]

Doherty's recent work continues to register that movement from the specific to the generic to which we have alluded, alongside the related expansion of the geographical terrain that falls within its purview. It also, however, registers simultaneously a more circular, contractive movement of repetition and return. This compulsive repetition, which

I have characterized elsewhere as resembling, on the one hand, that of a dissatisfied investigator drawn ineluctably and repeatedly back to the scene of a particularly intractable crime and, on the other hand, a comparable urge on the part of the crime's perpetrator, is especially evident in the video-installation *Re-Run* (2002; pp. 88–91).[15] On two screens facing each other we see a man in a black suit and tie running as fast as he can at night along a bridge lit by fluorescent lights. On one screen he is running towards us; on the other he is running away from us. The footage, in both cases, is silent and looped, so that it appears that this apparently desperate figure will never truly escape from whatever it is he is running away from or finally reach his destination, wherever that may be. These heavily edited scenes include footage shot from various angles, with an emphasis on the low angles favoured by Hollywood *film noir*, that classic cinematic genre epitomizing narrative convolution and moral ambiguity.[16] If we are familiar with Derry we will recognize this location as Craigavon Bridge, which crosses the River Foyle, dividing the mainly Catholic, Nationalist west bank from the predominantly Protestant and Loyalist east bank. If we are also familiar with Doherty's early work, however, we will realize that we are being returned to a scene he first visited in the photographic diptych *The Bridge* (1992; pp. 110–11), which depicts this same scenario from both angles, though deserted and in daylight. *The Bridge*, which was one of the earliest photographic works in which Doherty dispensed with textual overlay, in turn echoes the earlier photo-textual diptych *Strategy: Sever/Isolate* (1989; pp. 102–03), which juxtaposes a shot of Belfast's Westlink Bridge, which effectively separates the Catholic Lower Falls area from the city centre, with a shot of a pedestrian bridge leading to the once notorious Divis Flats. It appears that for Doherty there is no going forward without going back.

This is not to suggest, however, that there is no way forward, period. In a number of key works produced in 1995, most especially the three photographs

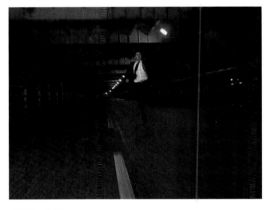

Re-Run, 2002

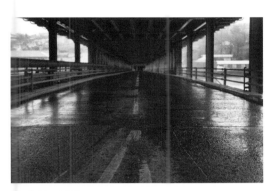

The Bridge, 1992

Uncovering Evidence That the War is No Over I, 1995

entitled *Uncovering Evidence That the War is Not Over I, II* and *III* (p. 127), Doherty sounded a cautionary note amid the understandable but premature euphoria, and what appeared to be a communally willed amnesia, that surfaced in Northern Ireland in the wake of the first IRA ceasefire. As we have seen, *30th January 1972* had previously suggested that collective forms of remembrance may be more complex and inclusive than those advocates of the purgative powers of willed amnesia as a panacea for Ireland's ills might have us believe. While Willie Doherty's work since the mid-1980s has worried again and again over memories of 'The Troubles', troubled memories, and the trouble *with* memory, it does so from a position of constructive criticality rather than one of destructive fatalism. As Paul Ricoeur reminds us, "there can be an institution of *amnesty*, which does not mean *amnesia*". That is to say that while at certain moments in history we have both a duty to remember and a duty to forget, these aims are neither comparable nor symmetrical, because, as Ricoeur puts it, "the duty to remember is a duty to teach, while the duty to forget is a duty to go beyond anger and hatred".[17]

1. For a description of the work, as well as a reproduction of the two projected images and a transcription of the featured interview samples, see Katherine Wood, Robin Klassnik and Liam Kelly (eds.), *Willie Doherty: Same Old Story*, exhib. cat., London, Derry and Colchester 1997, pp. 16–20.
2. Richard Kearney, *On Stories*, London 2002, p. 54.
3. This account of *Shoah* and the quotation from Lanzmann is taken from *ibid.*, pp. 50–55. See also Kearney's 'Narrative and the Ethics of Remembrance' in *Questioning Ethics: Contemporary Debates in Philosophy*, ed. Richard Kearney and Mark Dooley, London and New York 1998, pp. 18–32.
4. See Frederick Crews (ed.), *Memory Wars: Freud's Legacy in Dispute*, New York 1995.
5. Christopher Bollas, 'The Functions of History', in *Cracking Up: The Work of Unconscious Experience*, London 1995, p. 103.
6. Reich is quoted in Kearney, *op. cit.* note 3, pp. 23, 25–26.
7. Daniel Jewesbury, 'Walter's Garage (A Set of Tools)', in *Willie Doherty: How it Was*, exhib. cat., Belfast, Ormeau Baths Gallery, 2001, unpaginated.
8. *Ibid.*
9. Ulrich Loock, 'This is not a work of art (Marcel Broodthaers) – Willie Doherty', in Carolyn Christov-Bakargiev, *Willie Doherty: In the Dark. Projected Works/Im Dunkeln. Projizierte Arbeiten*,

Bern 1996, pp. 5–8.
10. See Jean Fisher, 'Seeing Beyond the Pale: The Photographic Works of Willie Doherty', in *Willie Doherty: Unknown Depths*, exhib. cat., Cardiff, Derry and Glasgow 1990, unpaginated.
11. *Ibid.*
12. See my 'Willie Doherty's *True Nature*', in *Willie Doherty: True Nature* (Renaissance Society of Chicago, forthcoming) from which the account of *Same Difference* and *They're All the Same* has been adapted. The reference is to Mikhail Bakhtin, *The Dialogic Imagination*, Austin TX 1981 (ed. Michael Holquist; trans. Caryl Emerson and Michael Holquist), p. 360, and Robert J.C. Young, *Colonial Desire: Hybridity in Theory, Culture and Race*, London 1995, p. 23.
13. Doherty acknowledges this shift in the course of a recent interview with Declan Sheehan, '"Perhaps" is Practically a Lie', *CIRCA* 99, spring 2002, pp. 17–19.
14. This account of *Extracts from a File* borrows from my review of the work as exhibited at the Kerlin Gallery, Dublin, in *Artforum*, February 2001, p. 164.
15. See my review of Doherty's 1998 exhibition *Somewhere Else* at the Tate Gallery, Liverpool, in *Artforum*, February 1999, pp. 106–07.
16. See Maité Lores, 'The Streets Were Dark with Something More than Night: Film Noir Elements in the Work of Willie Doherty', in *Willie Doherty: Dark Stains*, exhib. cat., Donostia-San Sebastián, Koldo Mitxelena Kulturunea 1999, pp. 110–17.
17. Paul Ricoeur, 'Memory and Forgetting', in Kearney and Dooley, *op. cit.* note 3, p. 11.

INSTALLATIONS

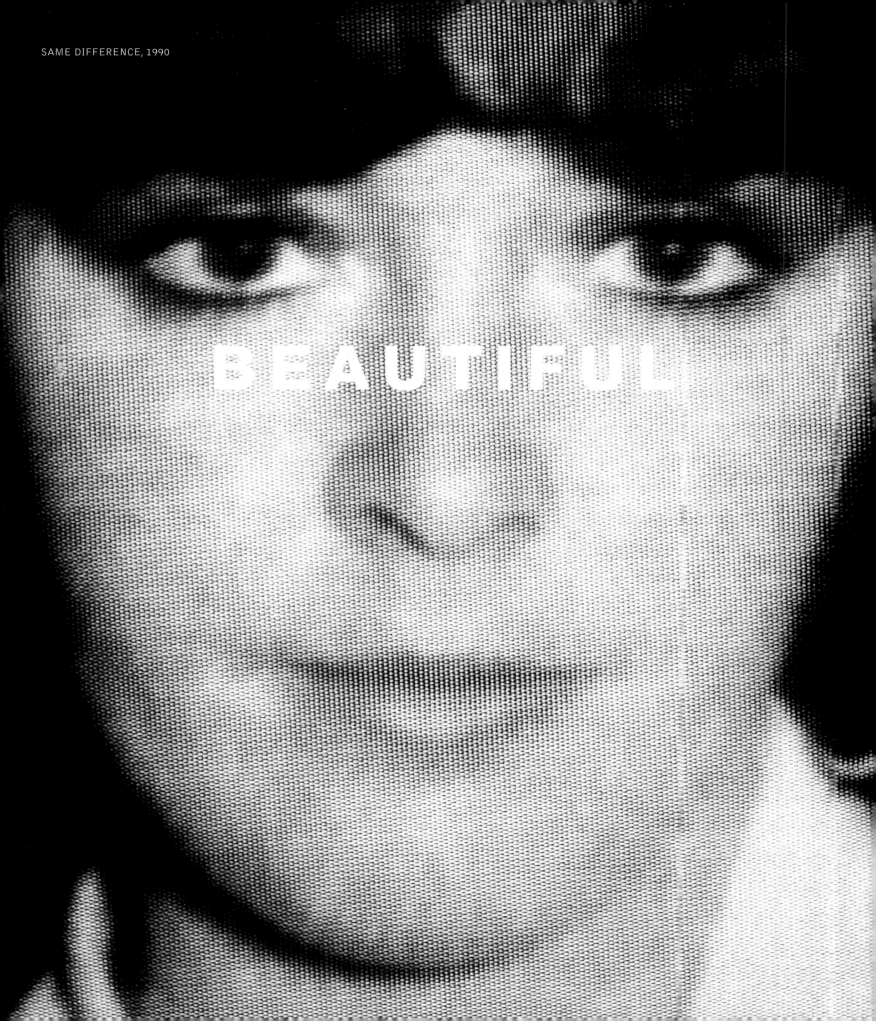

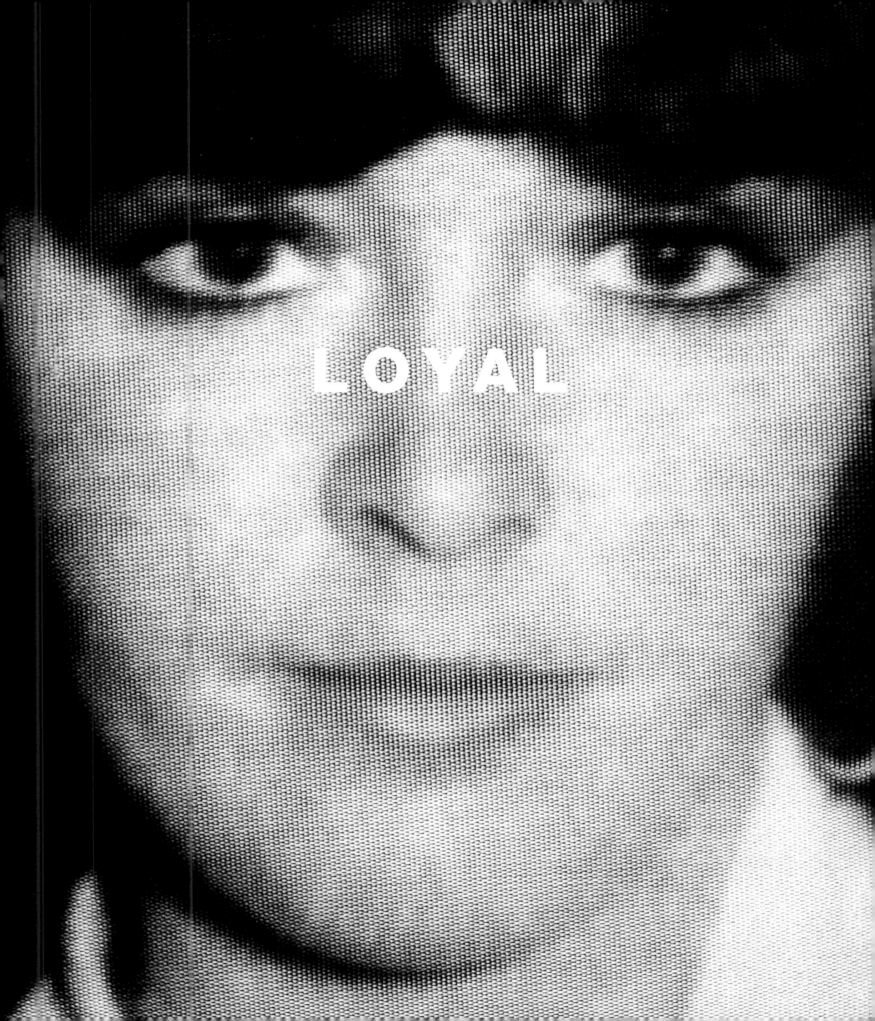

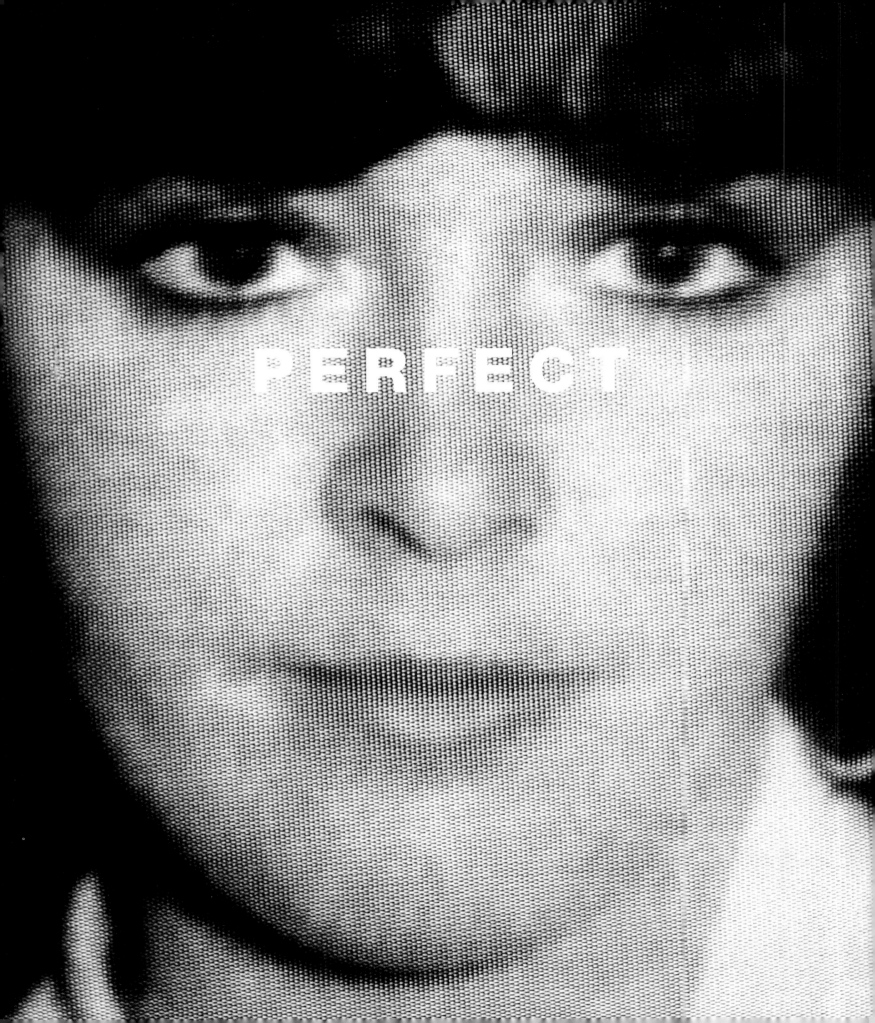

The clean sweet air is interrupted only by the lingering aroma of turf smoke.
I'm pathetic.
The verdant borders of twisting lanes are splattered with blood-red fuschia.
I'm barbaric.
Nowhere is the grass so green or so lush.
I'm decent and truthful. It's in my bones.
Nowhere are the purples and blues of the mountains so delicately tinged.
I am ruthless and cruel.
Nowhere is the sea so clear and calm, and, with barely a moment's notice,
the waves so dark and angry.
I am solid.
Nowhere has the sky such a range of delicate blues and mysterious greys.
I am essentially evil.
The sky is at its most dynamic in the West, where it is contrasted sharply
against the white limestone walls.
I never saw such walls.
They represent the blood and sweat of countless generations. For all this
land is 'made' land, hand made.
I am proud and dedicated.
For me, there is no alternative.
Upon seeing the grey barrenness of this limestone country one of
Cromwell's generals complained, "There is not enough timber to hang
a man, enough water to drown him, or enough earth to bury him."
I am uncivilised and uneducated.
On a clear day, when there is no haze to obscure the view, it is possible
to gaze across the open landscape.
I have its history in my bones and on my tongue.
It's written all over my face.
Rain or shine, there are few landscapes whose colour, scale and contrast
impress so immediately.
I'm crazy.
Nowhere are the nights so dark.
So dark that you cannot see the end of the road.
I'm innocent.
I'm cynical.
Nowhere is the sand on the beaches so fine and white.
I am patient. I have a vision.
Smooth, age-worn stones wet with rain.
Even the rain is different there.
The soft Atlantic rain which often seems to cover the whole country adds
depth and subtlety to its colour.
I am dignified.

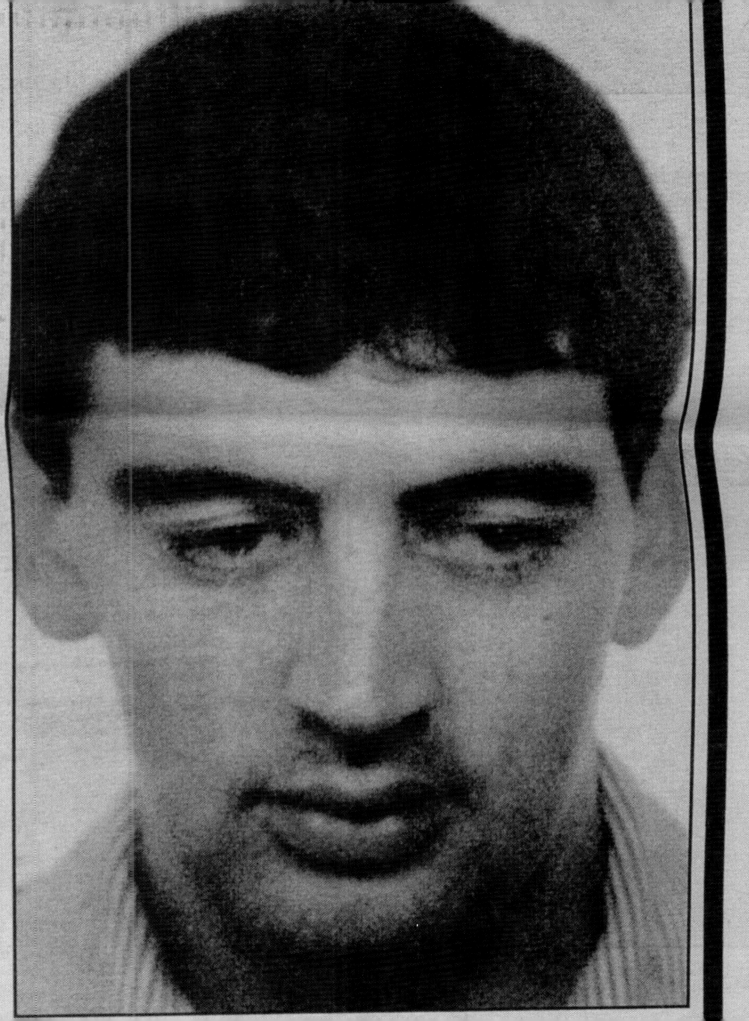

were
er an
under
their
flee
and a

being
men in
uggled
Iass at
Brixton

on offi-
ot and
street
in his

ectives
know
un.
Baker
added:
f this
on."
at the
, from
public,
Stra-
us and

f Com-
-Cole-
led the
kinson,
ughing

tegory
yester-

in the
em by

gled in
of staff

cretary
ssocia-
emely
in the
to be a
, were
charges
last

... I was diagnosed that day as a diabetic, ye know, and I was up in my mother's house in
Creggan and then I came down to Blucher street and I was crossing over here to the mother-in-law's
when I heard the shots ringing out, so I ran back and hid behind the gable wall over there ...

... everybody was just devastated that day ...

... one of the men went out with his hands up, all of a sudden there was a crack and he just went down ...

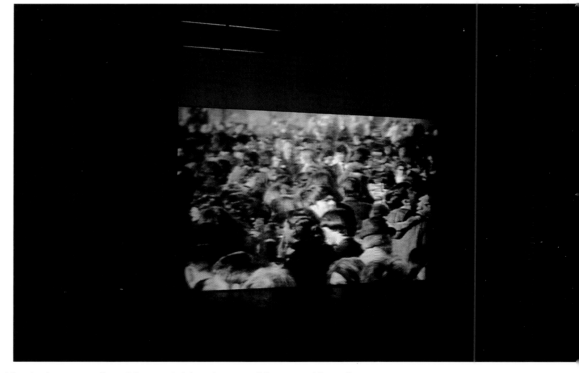

... a very good friend of ours, we
all lived in the flats together,
was shot that day.
That was a young fella by the
name of Hugh Gilmore, and ah ...
I think I was the last person
he spoke to, to tell me that
he was hit.

"I'm hit ... I'm hit!" ...

... Bloody Sunday will
always be Derry ...

... he was lying, blankets covering him and blood was all over the place ...

... I didn't know him, I didn't hear who it was, but I could see him lying
and people roaring and squealing to get down for cover ...

... it was just mayhem ...

... I remember the fear taking over me and getting up and running and everyone shouting to get down, and running
through the high flats and seeing the bodies lying there. Now for months after that I used to
waken up with cold sweats, at two or three in the morning ... just waken up with cold beads of sweat on me ...

... people talked about how the skies were even crying ...

... the only image I have about Bloody Sunday is that the people were innocent ...

... Ah ... It was tragic ... it was tragic ...

... everyone went out, I would say, in a happy mood ...

... on the other side of the flats was a man lying with a sort of a banner around his head and I remember walking over and seeing his eyelash on the wall ... Somebody took it off the wall and put it in a matchbox and put it inside his pocket ...

... it was just a massacre that day ...

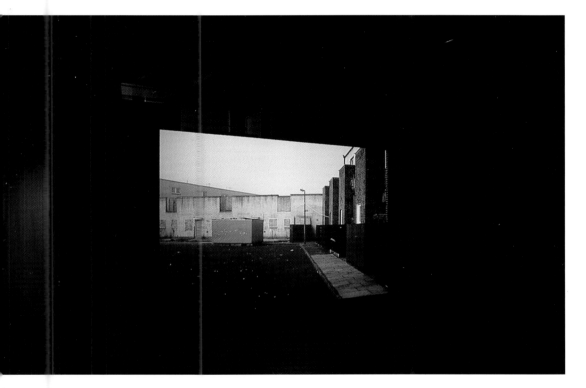

... his companion's head exploded just like you'd see it on a film ...

... he lost his shoe and there was a kind of a push forward, I think it was to see what was happening further down the street, but we were away at the back, so I took him over to my house to get him another pair of shoes and that's when all the shooting happened ...

... one man was brought in there and when they took his jumper off part of his back fell out where he was shot ... he was shot in the back twice ...

... it was a terrible day for this community as a whole and it stayed with everybody for years ...

... it should never have happened ...

... there was just hysteria ...

... you couldn't get back into the chapel for the funeral, it was just packed out, but seeing the thirteen coffins lined up in front of the altar the night before was very very moving ...

I worry about driving the same route every day ... Maybe I should try out different roads ... alternate my journey.
That way I could keep them guessing.

I don't remember now when I started feeling conspicuous ... A legitimate target.

I've been watching him for weeks now
He does the same things every day ... Sadly predictable, I suppose. The fucker deserves it

We've known about him for a long time but we've been waiting for the right moment.
Waiting for him to make a move.

I keep thinking about this guy who was shot ... I remember his brother said "We were both sitting having a cup
of tea watching the TV when I heard this loud bang at the front door ... We both jumped up to see what
it was, he was nearer the door than me and got into the hall first ... But by that time the gunman was
also in the hall and fired three or four shots directly at him ... point-blank range ...
I'm a lucky man because then he panicked and ran out to the street where a car was waiting for him."

Sometimes I feel like I'm wearing a big sign ... "SHOOT ME"
As far as I'm concerned he's a legitimate target

The only good one is a dead one.

If I'd had the shooter earlier I could have had him a dozen times.
Dead easy! ... I've walked right up behind him, looked straight at the back of his head ...
He was wearing a checked shirt and faded jeans ... He didn't even notice me
and I walked straight past him.

I'm certain that my phone's
bugged and that someone is
listening to my conversations ...

Every time I lift the receiver
to answer a call I hear a loud click ...
as if someone else is lifting the phone at the same time ...
I'm not imagining it because some of my friends also hear this strange noise when they call me ...
My anxiety increases when my phone rings occasionally in the middle of the night. This is totally inexplicable as no
one would want to ring me at three or four in the morning ... It scares the hell out of me ... I think that my
killer is ringing to check if I'm at home.

He reminds me of someone ... Maybe someone I went to school with.

I feel like I know this fucker ... I know where he lives, his neighbours, his car ... I'm sick of looking at him.

I saw a funeral on TV last night. Some man who was shot in Belfast.
A young woman and three children standing crying at the side of a grave. **Heartbreaking.**

One morning, just before I left home at half six, I heard a news report
about a particularly savage and random murder ... That's how I imagine I will be shot ...
as I drive alone in the dark I visualize myself falling into an ambush
or being stopped by a group of masked gunmen.
I see these horrific events unfold like a scene from a movie ...

I was very relieved when dawn broke
and the sky brightened to reveal a beautiful clear winter morning.

He drives the same road every day, buys petrol at
the same garage ... It'll be easy. No sweat!

I can't stop thinking about the awful fear
and terror he must have felt ...
Maybe it was so quick he didn't know a thing.
I can almost see myself waiting for him along the road.
It's fairly quiet so it should be safe to hide the car
and wait for him as he slows down at the corner ...

A couple of good clean shots should do the job.

This particular part of the road is very shaded.
Tall oak trees form a luxuriant canopy of cool green foliage ...
The road twists gently and disappears at every leafy bend.

As my assassin jumps out in front of me everything starts to happen in slow motion.
I can see him raise his gun and I can't do a thing. I see the same scene shot from different angles.
I see a sequence of fast edits as the car swerves to avoid him and he starts shooting. The windscreen explodes
around me. I see a clump of dark green bushes in front of me, illuminated by the car headlights.
The car crashes out of control and I feel a deep burning sensation in my chest.

In the early morning the roads are really quiet ... You can drive for ages without passing another car ...
The landscape is completely undisturbed and passes by like some strange detached film.
It might be just as easy on the street ... I could wait until he's coming out of the house or I could just walk up
to the door, ring the bell and when he answers ... BANG BANG!... Let the fucker have it.

It should be an easy job with a car waiting at the end of the street ...
I've seen it so many times I could write the script.
In the past year I've had some really irrational panic attacks ...
There is no reason for this but I think that I'm a victim.

At the end of the day
there's no going back.

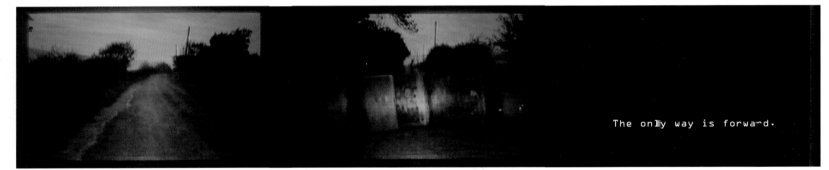

We're all in this together.

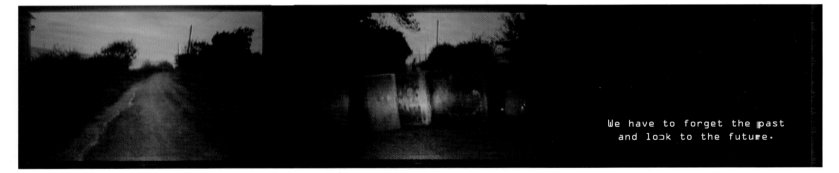

The only way is forward.

We have to forget the past
and look to the future.

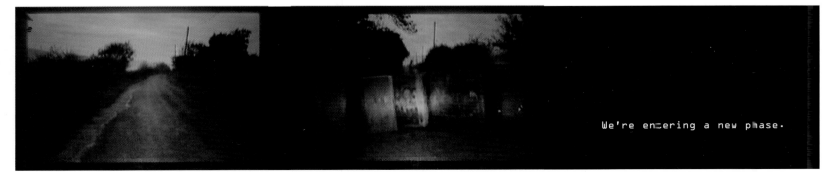

We're entering a new phase.

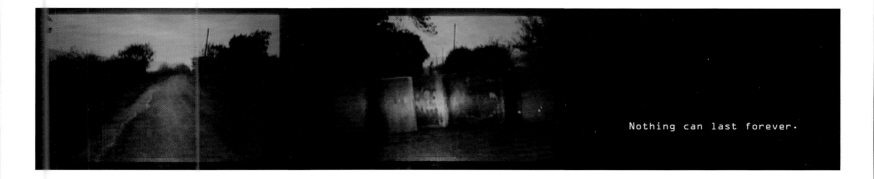

Nothing can last forever.

Let's not lose sight
of the road ahead.

There's no future in the past.

At the end of the day
it's a new beginning.

Let's not repeat
the mistakes of the past.

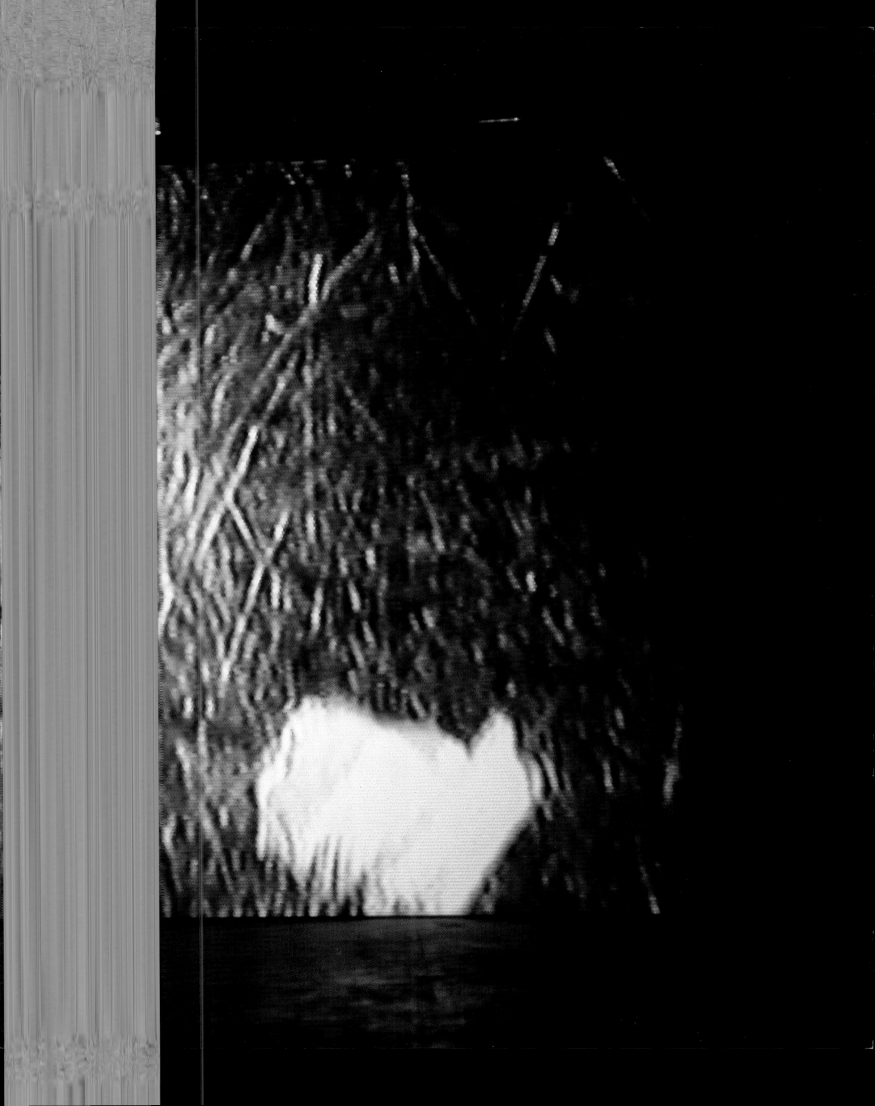

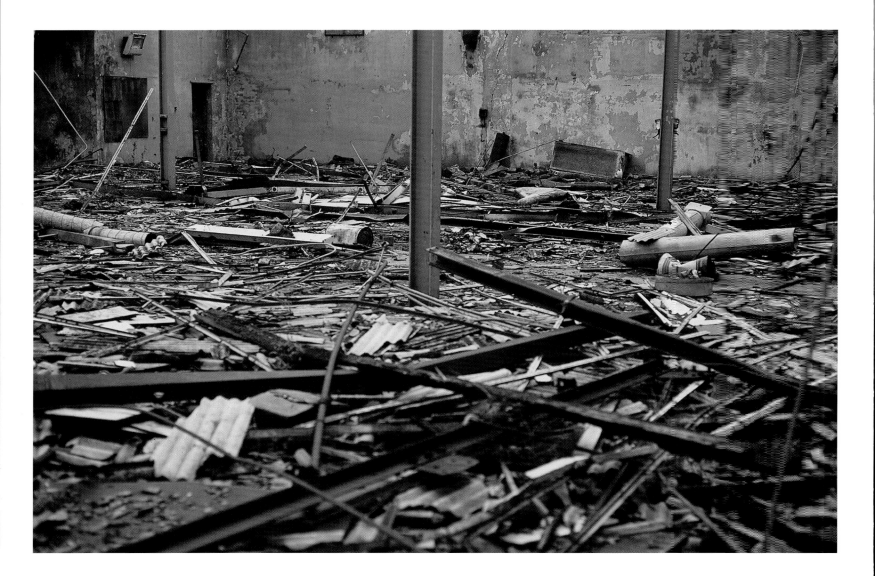

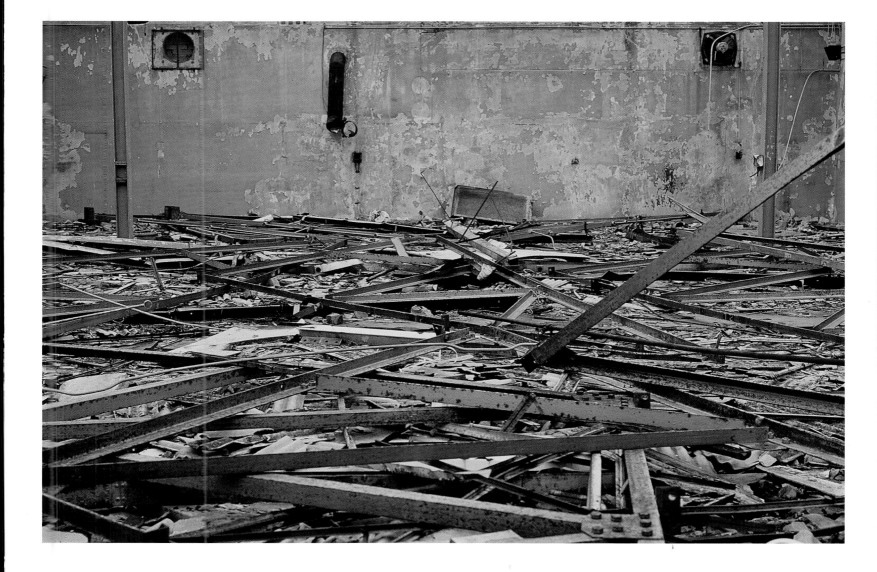

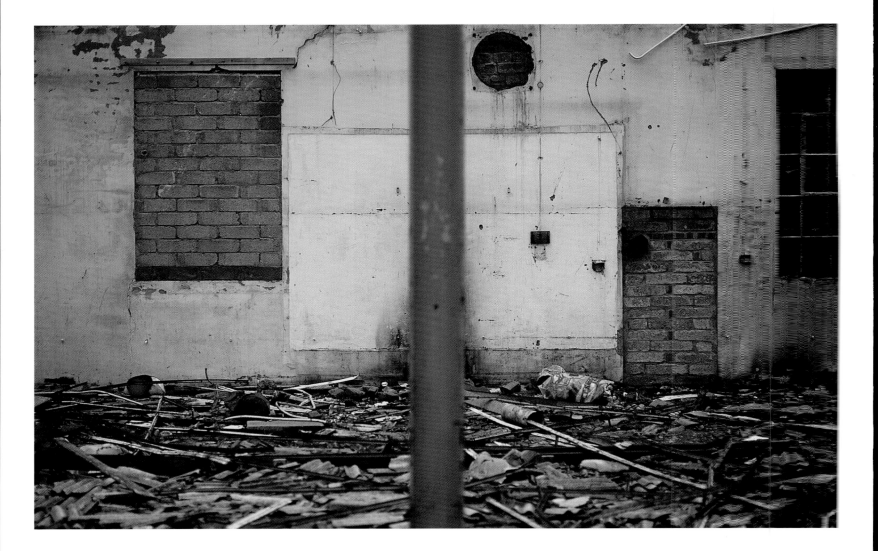

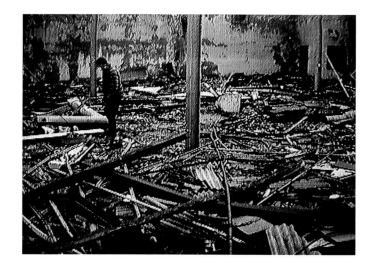

Man: ... I never thought that it would happen to me.

You know how it is ... It's always someone else. Someone you don't know.

... She didn't look like the sort of woman
who would be involved in that kind of thing,
was very quiet, kept herself to herself.

I couldn't believe it when I heard she was dead. It was like a dream.

... As soon as I saw him I knew he was one of them.

He had a certain look on his face. After that he was a fucking dead man.

... I hate walking alone in the country. I feel exposed and vulnerable.
I keep thinking someone is watching me or following me and I can't see them.
I'm also frightened that I might find a body that has been hidden in the bushes.

... One night I had a dream I was taken prisoner.
I was blindfolded and held in a small room.
I lost all track of time, I don't know how long I was in there.
Eventually three men came into the room.
They tied me to a chair and asked me questions about my life.
I thought they were going to kill me.

... I didn't know what was happening at the time. Like everyone else I read the newspaper reports and saw it on TV.
As soon as I saw the body lying in the grass I knew it was her ...

I recognized the pattern of her jumper.

... I knew there was something going on even though no one was talking
about it.

I could smell trouble ... I could feel the tension.

I wanted to find clues ... I went looking for evidence.

Look! ... the photographs prove everything.

... I never thought that it would happen to me.
You know how it is ... It's always someone else.

Someone you don't know ...

Woman: The first time I met him was in 1989, I thought he was okay but
a little crazy sometimes. But I never thought he would do that.

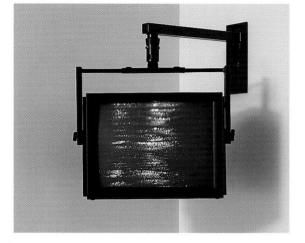

 ... You hear all kinds of stories about people
 being watched and their house being bugged.
 I never really believed it, to tell you the truth .

 I wasn't even suspicious.

 I never heard any noise, never saw anything.
I had no idea that there was someone listening to me ... watching me.

 ... I never thought that it would happen to me.

 You know how it is ... It's always someone else. Someone you don't know ...

... Well, I was just walking down the street when I suddenly saw this guy being led away by a bunch of cops.
 I didn't recognize him at the time, but I found out later who he was.

 ... She didn't look like the sort of woman who would be involved
 in that kind of thing, was very quiet, kept herself to herself.

I couldn't believe it when I heard she was dead. It was like a dream.

 ... I hate walking alone in the country.
 I feel exposed and vulnerable.
 I keep thinking someone is watching me or following me and I can't see them.
 I'm also frightened that I might find a body that has been hidden in the bushes.

 ... Her body was found dumped on a track near the border
 by a woman out walking at 7 am.
 Several hours earlier there had been reports of shots
 being heard in the area.

 The first time I met him was in 1989,
 I thought he was okay but a little crazy sometimes.

 But I never thought he would do that.

SAME OLD STORY, 1997

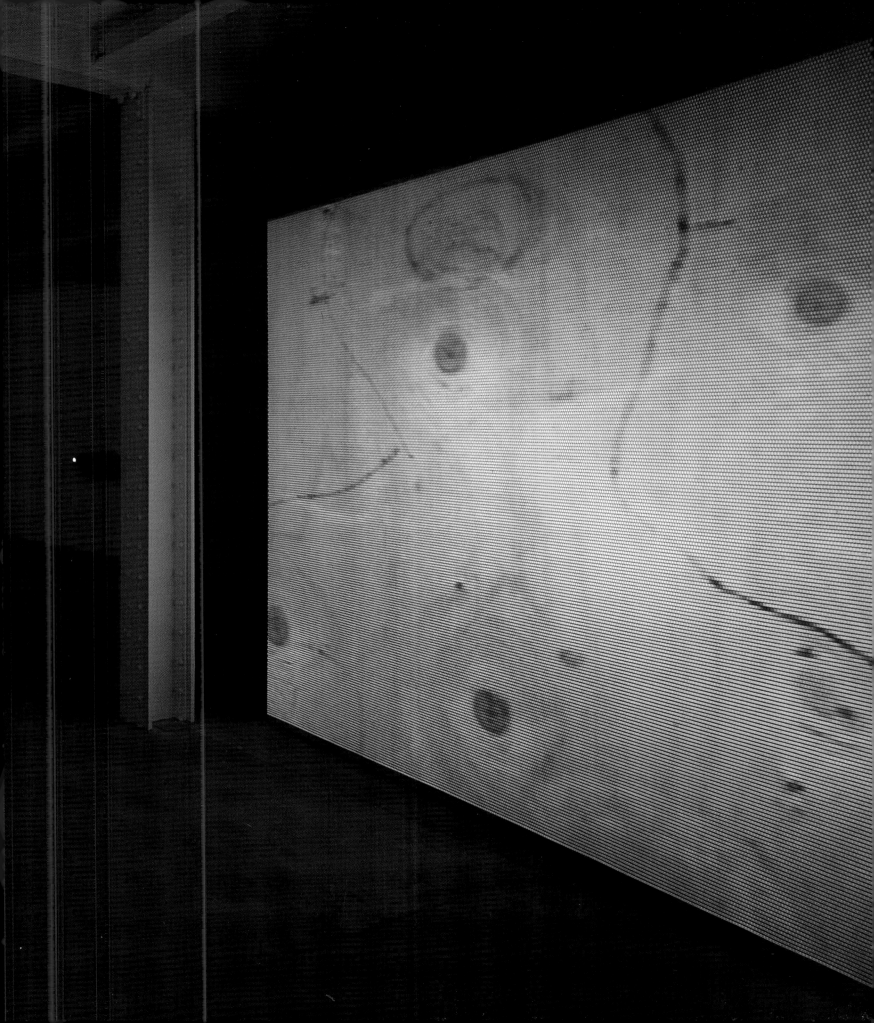

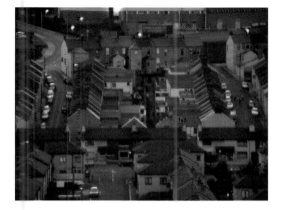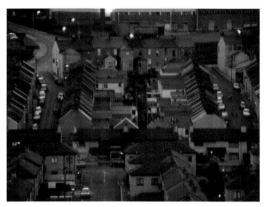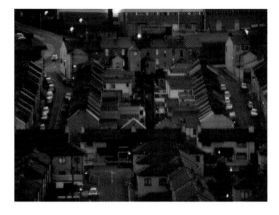

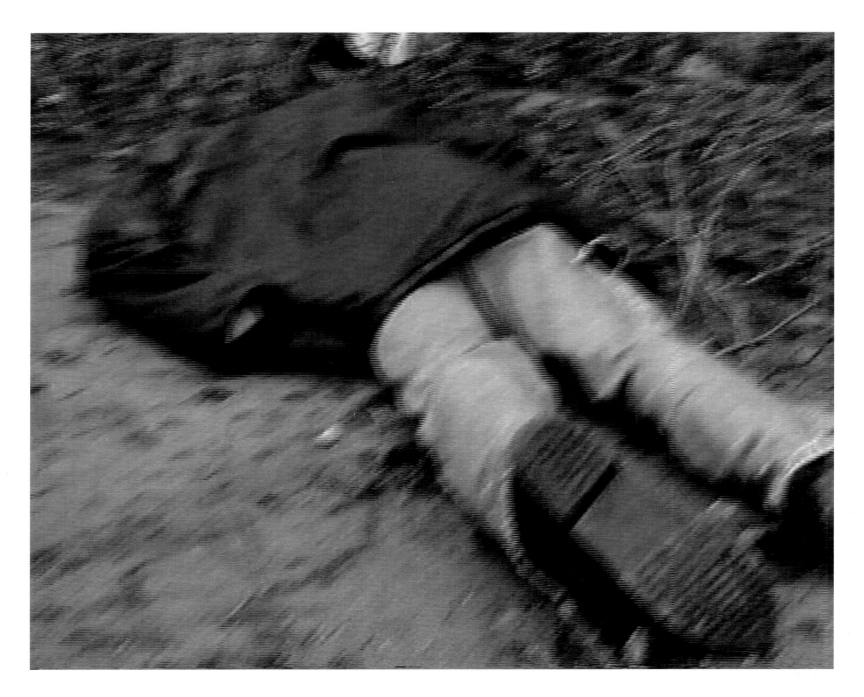

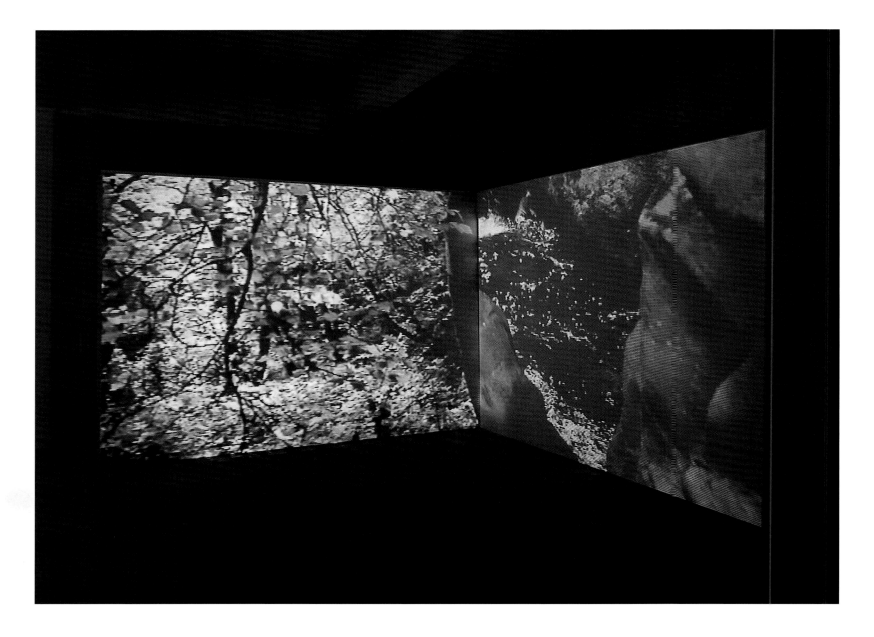

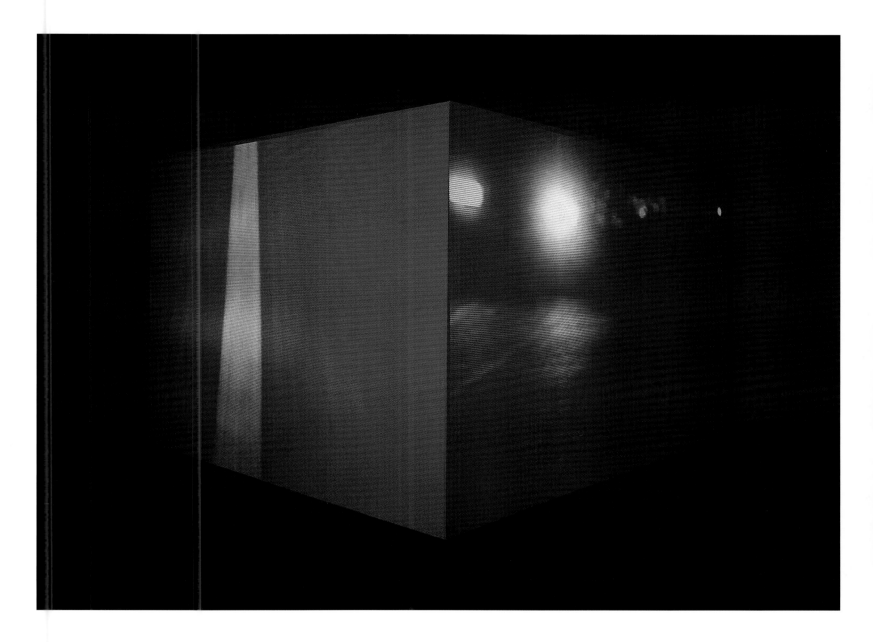

Fade up to a scene in a forest.

A man walks along a cool shaded path.
He moves cautiously.
He has parked his car some distance away as he doesn't want to attract any undue attention.
The camera follows him from behind.
He comes to a small clearing in the trees and stops to listen to the distant sound of a small river.
As he looks around we see him from above.
A high crane shot gives us this unnatural vantage point.
We see him and he doesn't even know we're watching him.

Let's start at the beginning.

It's a straightforward story, with a twist.

For the purposes of clarity, let's say it's about a man in two places at the same time.

A double life.

Who said things were going to be simple?
Things are never what they seem.
There's always something waiting just around the corner.

Meanwhile, he arrives for the meeting.

Fade up to a wide shot of a disused industrial landscape.

He stops the car beside a line of old storage units.
As he waits his concentration slips and he remembers a dream he had the previous night.

He is in a forest.

It is the middle of the night.

He's walking towards a distant light, barely visible between the trees.
As he approaches he can hear a scraping noise.
Eventually he is close enough to observe two men digging a hole.

Then they drag his body from a car and throw it into the hole.

The following scene happens simultaneously somewhere else.

A nondescript stretch of country road.

The camera looks straight up the road, focused on a point somewhere in the distance.
After a few minutes a car appears around a bend in the road.
It continues to drive along the road, steadily getting closer and closer to the camera.
Unexpectedly, the car stops and an unknown man gets out of the car and drops an unidentified object
into the hedgerow at the side of the road. He gets back into the car and drives off.

He's starting to lose it.

He struggles to keep a hold on things. A grip on reality.

His body was discovered in a foul-smelling pit of the decomposing remains of dead farm animals. He had been beaten so badly that police were only able to identify him from one fingerprint and his dental records.

Meanwhile, a helicopter hovers above the countryside, close to the border.
Inside a video screen flickers with the infrared image of a ditch.

Interior. Badly furnished flat. Night.

The only light comes from the glow of a television in the corner.

He is alone, lying on a sofa, intently watching a newsprogramme.
He has fantasies about getting out.
He barely remembers how it all started any more, but it has got seriously screwed up.
Sometimes he closes his eyes and imagines he's on a beautiful beach.
Somewhere on the west coast when things were a lot simpler.

A flash of car headlights. Interior of a car. Night.

He is driving. He is trying to concentrate but sometimes it feels like his brain is splitting in two.

At the far side of the beach the soft contours of the sand are broken by huge bulks of grey rock.
The rocks seem to be both an intrusion in the path of the sea and an echo of the shape of the water.
Their strange forms have been created by years of exposure to the incessant patterns of the tides.
One looks like the head of a shark, another snakes along the sand. Others are both familiar and unknowable.

There's been a tip-off.

Everything is in place. Nothing can ever be the same again. It's over apart from some last-minute details.

Exterior. A high vantage point overlooking the city. Dusk.

The camera is fixed on this scene with a wide angle.
After five or ten minutes small dots of light begin to appear as the street lights below are switched on.
Very slowly, almost imperceptibly, the camera begins to zoom in on the distant city.
Gradually the frame is filled only with buildings.
The long slow zoom continues relentlessly until a single window is framed neatly in the viewfinder.

He saw him recently on television.

He couldn't believe it was him. He looked for some visible sign of remorse or regret.

Nothing.

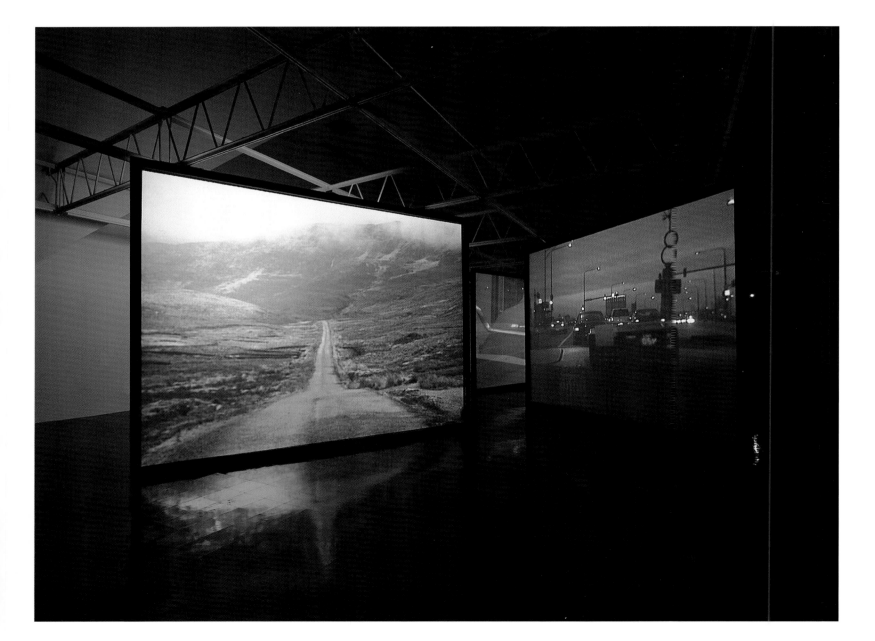

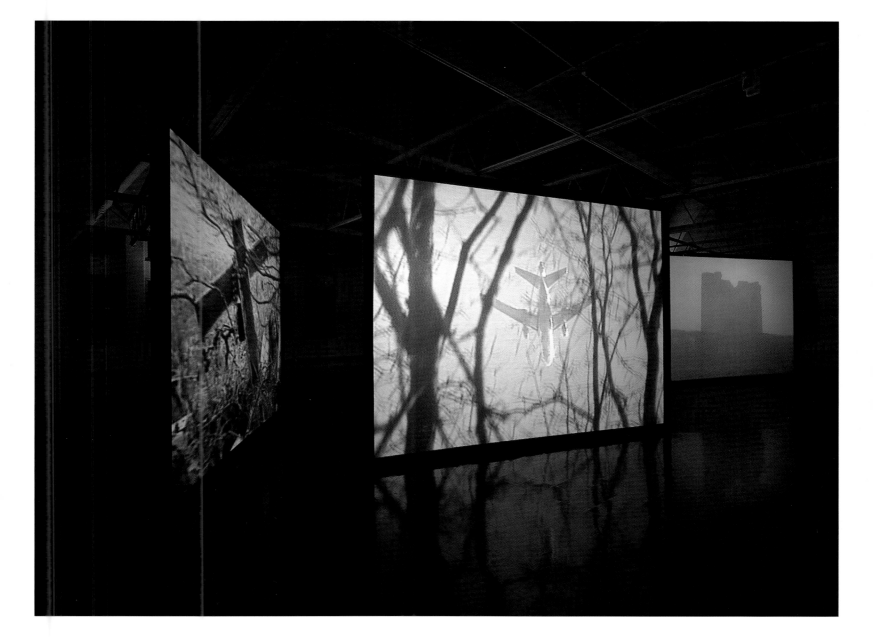

Narrator: He knew that he would never go back.

 Woman: A lot of people in my family like to read fantasies. Science fiction and fantasies.

 Woman: When she came here, she was a domestic, which means she lived with ...
 you know, a wealthy family and took care of their children.
She married late for the times, you know. That's what she used to tell me.
 She married when she was, I think, twenty-eight, and she was older than my grandfather.
 And, ... you know his family disowned him because she was an immigrant, and they were old, you know, way back.

 You could trace them way back, and they just thought that she was beneath him.

 Man: American society is extremely mobile.
 You're expected to get up and go for business needs and everything else.
 And that is my idea for Eden, to just have a place, for better or worse that is your place,
 and that's my idea of Ireland.

 (pause)

 When I see, you know, people coming from over there and ... some people with
 a map of Ireland on their faces. And you know ... you know, wide-eyed, off
 to the new world, to do what they can do ... there's a ... it's a kindred
 spirit. I think Irish are the most human. My grandfather was Irish ...
 he was actually first-generation.

 Well, he was born there, but here when he was three years old.
 So, he certainly had an Irish influence because his parents were Irish.

Woman: It's definitely green, you know, and it's sunny and it's flat, relatively flat.
 That's probably from pictures I've recently seen ... of Ireland.
 But it's ... but there's a lake and it's sort of a medieval setting, you know.
 The castle I see is of course in ruins.

 But he never much beat the drum
for Ireland ... But he was a talker.

 Narrator: Perhaps now he can take his place. Be one of them.
He looked like one of them. He was even beginning to think like one of them.

Woman: She missed Ireland and she missed her sisters especially because ... because she had all brothers.

Man: I've seen all the pictures, the photographs, and the travel posters but I've also seen the newsreels. I've also seen the barbed wires.

And it's really paradoxical because the pastoral place, the Edenish place, the away place, I perceive it as NOT here ... and this is a big country.

You can go virtually any physical surrounding you like in this country, but urban life in a big city, like Chicago, is a grind.

You can't get any place. There's no time for anything ever.

The roads are torn up forever. And you think of a better place, of all these stereotypical images of Ireland.

Woman: I looked in <u>National Geographic</u> a few times and I saw my brother in a picture of Irish ...

Sure we've seen them and we say "Oh, that would be nice."

I mean, I saw my family standing there ... a picture of Irish children.

I saw our family.

People that, you know, we look like.

Narrator: The dark waves crashed incessantly against the rocky shore. The violent force of the sea always fascinated him. I was both exhilarated and frightened by such power.

Woman: I was raised thinking that there's royal blood in my Irish lineage. The story is that she was jealous of her husband's heritage.

She's Polish, and she didn't have it ... the same kind of pride, so she burned all the documents, and he died at age forty-two.

Actually, that was my dad's father, so I never met him. Anyway, so there's always been this idea in the family that there's, you know, a castle somewhere for us and there's land and a pond, a lake, and we should go see where this is, you know, this fairy-tale idea.

Narrator: He longed for the old, familiar places, but he knew that he had to go on.

Change was on the horizon.

Woman: I think if I went to Ireland, it would be with this sort of, and maybe this is why I haven't gone, expectation that I would feel something if I found 'the' place.

Woman: We lived with my grandmother ... well, in the same apartment building, and she lived on the second floor, so basically she was like a second mother to me.

Also, she died when I was a sophomore in high school.

They were very poor, and a lot of her cousins had come here, and she knew if she came here, they would, you know, basically set her up with a job and a place to live.

Narrator: Perhaps now he can take his place.

Be one of them.
He looked like one of them.
He was even beginning to think like one of them.

Narrator: When things got really complicated, he closed his eyes and thought of what it must've been like long ago. He imagined himself in a place so remote that there was no other visible sign of life.

Narrator: Everything was going well.
He could not accept this as he was afraid that someone would eventually discover the truth about him ... his true nature.

Man: My father was a drinker.
Never an alcoholic, just a drunk. Quit when he wanted to and not quit when he wanted to. When he got old and grey and the doctors said "Quit, you're going to kill yourself", he just stopped.

The magician. [laughs] But it's ... in my family, we are not wealthy people.

There was sort of a secret pride that no matter what your circumstances were, your group, the group ... was acceptable.

We cared about each other.

Not in any demonstrable way.

It was a safe place.

Woman: I'm a quarter Irish, a quarter Polish, a quarter Norwegian, quarter English. So why do I feel this pull toward my Irish heritage?

Narrator: Here he could be his true self. For the first time, he was in control. He would never apologize again.

Woman: Her real name was Bridget but when she came to America, she didn't want to be identified as Bridget
because it was a derogatory term like Paddy.
So she changed it to Mary. Not, I don't think, legally.

Man: They carry this sense of, they betray this sense of "I'm Ireland".

Ireland isn't back there.

If you took all the people off Ireland, there would be no Ireland.

Narrator: When things got really complicated, he closed his eyes
and thought of what it must've been like long ago.
He imagined himself in a place so remote
that there was no other visible sign of life.

Woman: It's the colour, you know ...
what stays in your mind is what you want to believe,
and what you want to believe is this is a beautiful green place
because you left it. And you want to remember.
When you go back there to visit, it's gonna be what you hope.

So, I think what sticks is the romantic images.

Man: Being Irish gives you the opportunity to be half hero, half traitor and then you have the option and the excuse.

Narrator It had been such a long
and difficult journey.

No one could imagine the
suffering he had endured.

He had arrived at
last, but the only problem was that
he was still haunted by an
inexplicable fear of screwing things
up, or behaving like he had in the
past.

Woman: All the Irish-Americans I
know are ... you know, they have a
lot of pride.

I would say more so than a lot of
other nationalities about and ...
maybe that's not true.

But, it's really funny.

It does seem to be.

Sometimes he felt that he was doomed to never escape.

Man: You can have an Irishman tell you a horror story and make you laugh by the way he tells it.
Between the bejesuses he's throwing in, and the ... then, you know, being thrown out by
bouncers and being chased by the police.

It's always a laugh. It's always a lark.

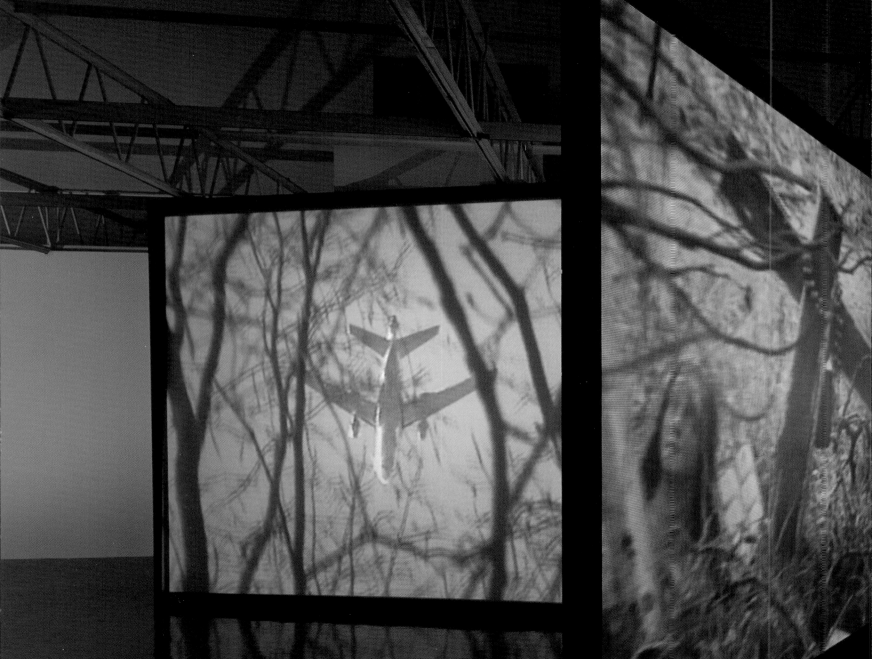

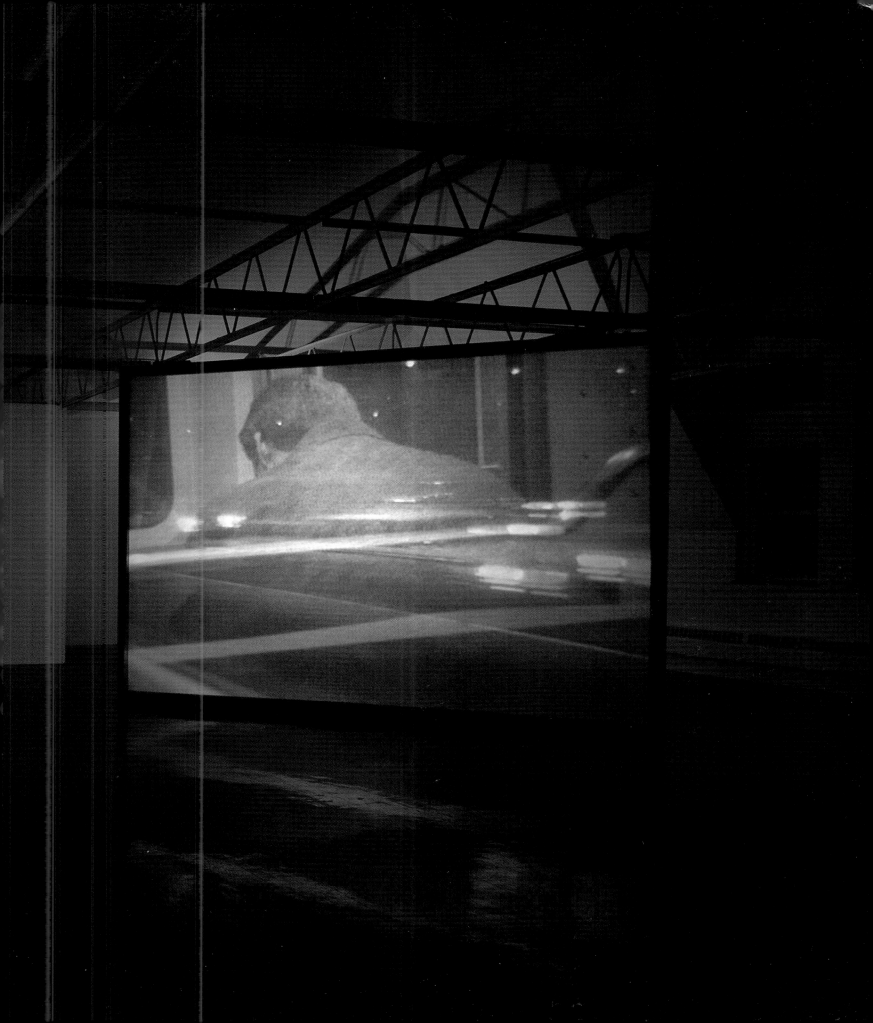

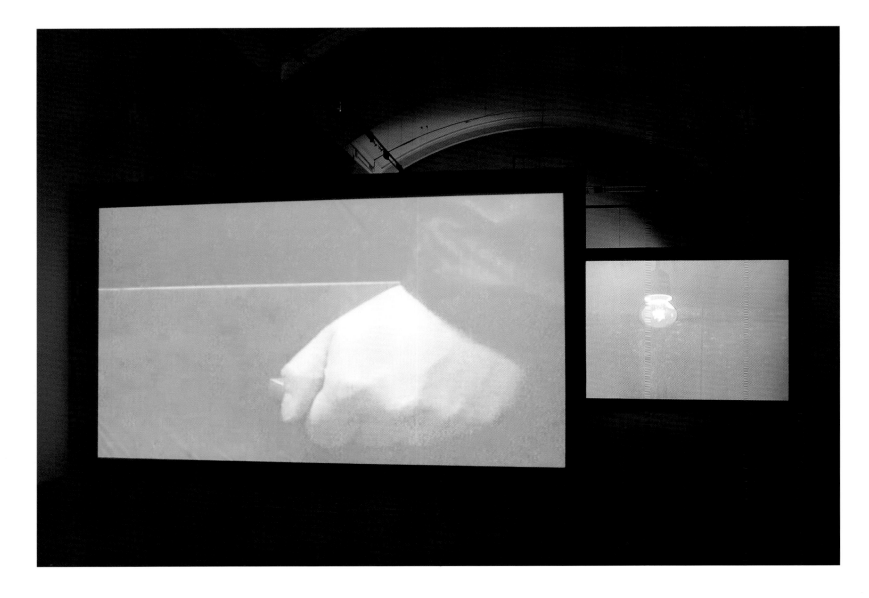

The light plays tricks at that time of day.

It all happened so long ago, it's like a different world.

 I didn't expect to find it in the drawer, but I thought I should look. At least look.

 There was no going back to check. Everything is changed.

 As if everything was covered in dust.

I wasn't in any hurry.

 As far as I was concerned I was alone and I could take as much time as I needed.

 His left hand was obscured. You couldn't see anything in the drawer.

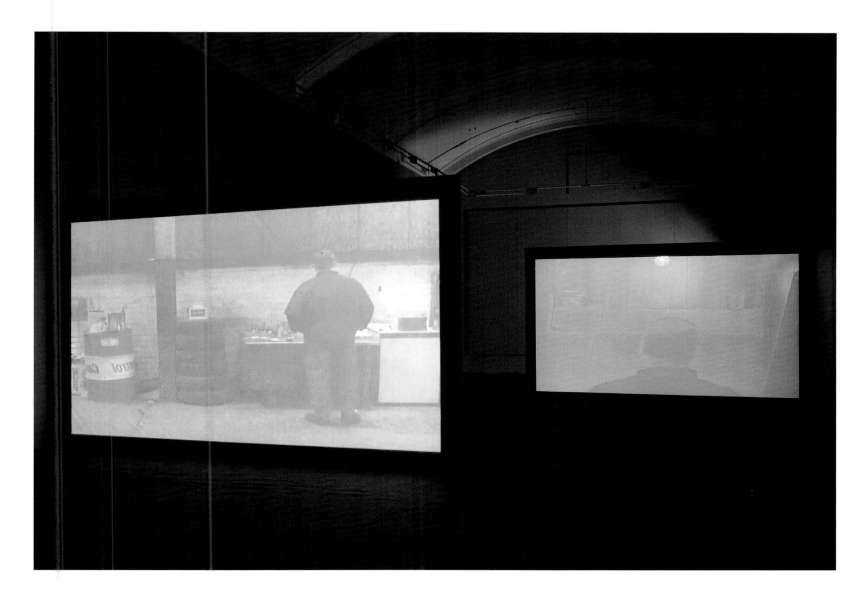

Everything is changed.

I was there and I have doubts.

There was a TV set in the small office. I'm not sure if it was on.

But I thought I should look. At least look.

As far as I was concerned I was alone and I could take as much time as I needed.

I remember it as a grey space. As if everything was covered in dust.

There was a hammer on the wall.

By the late afternoon everything was over.

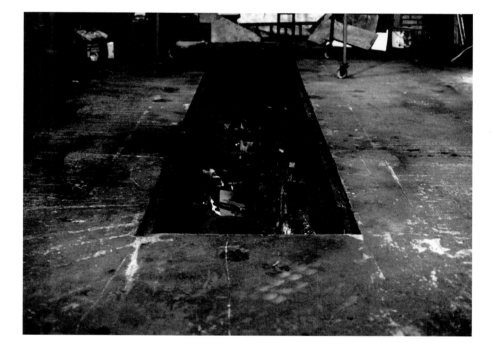

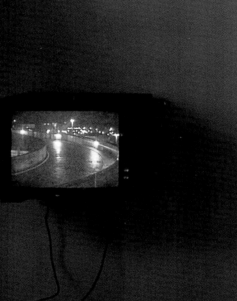

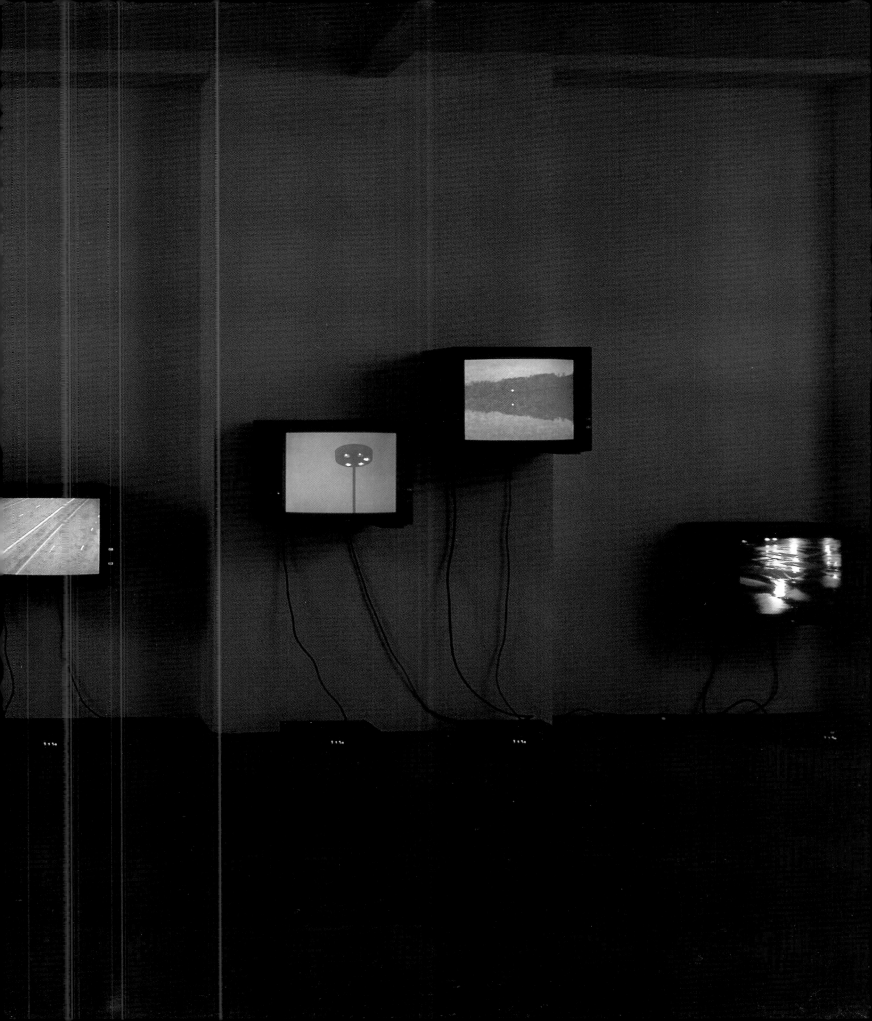

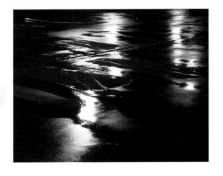

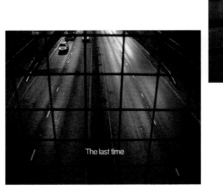

The last time

April 29, 1994

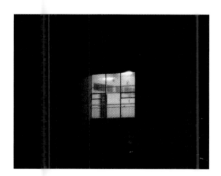

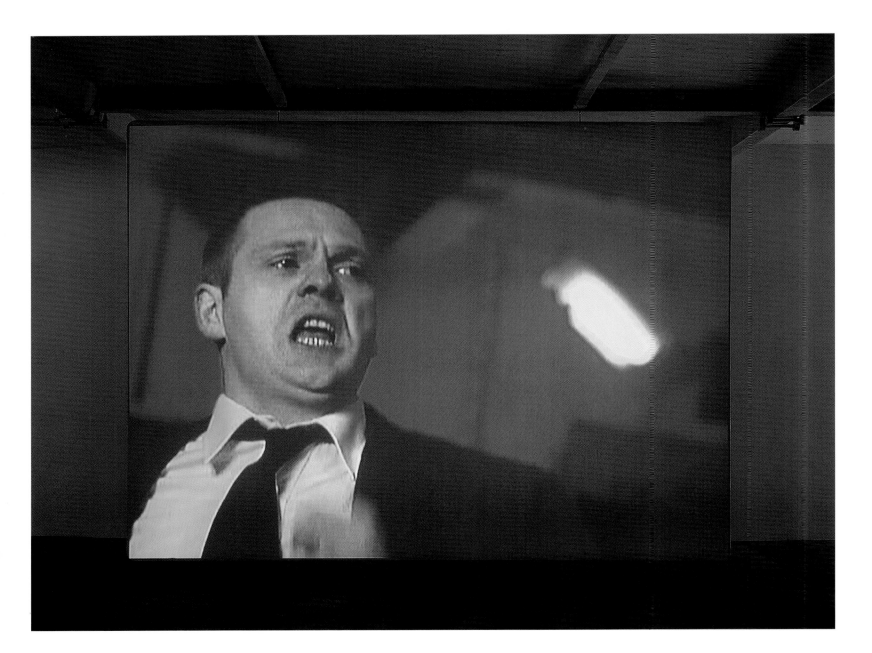

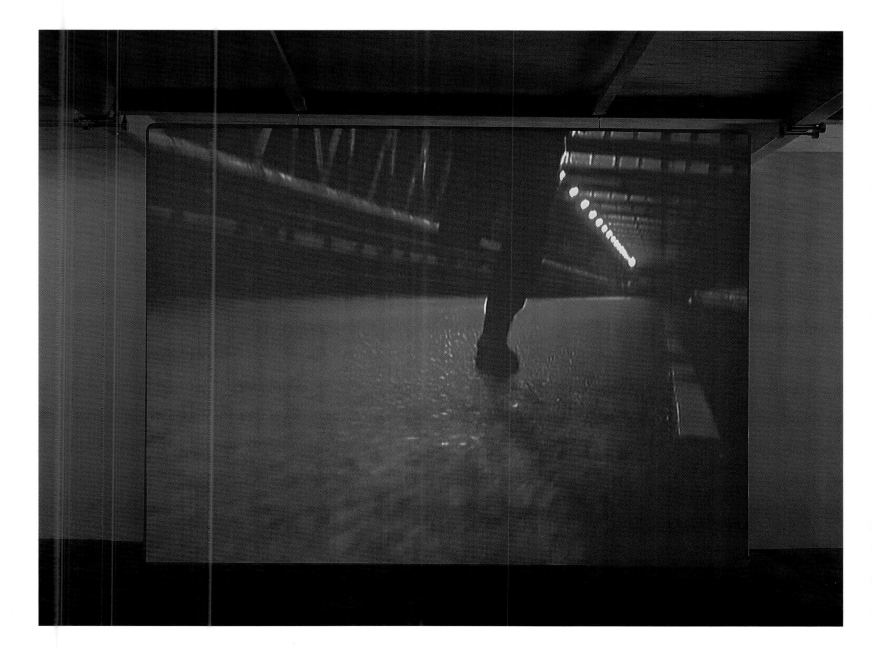

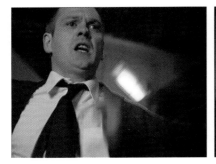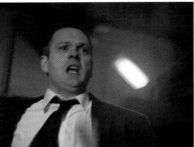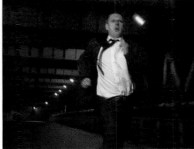

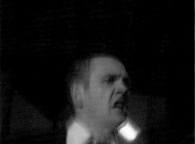

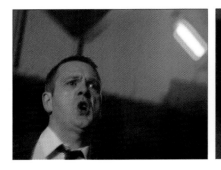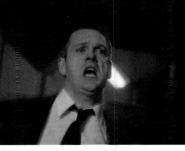

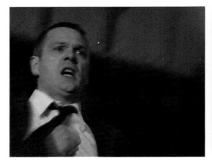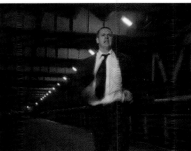

PHOTOGRAPHS

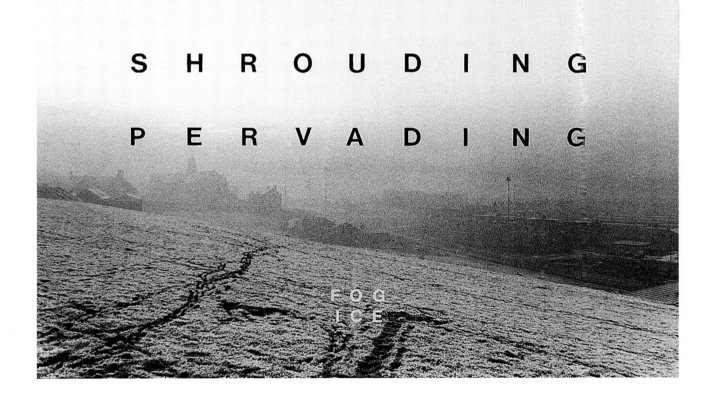

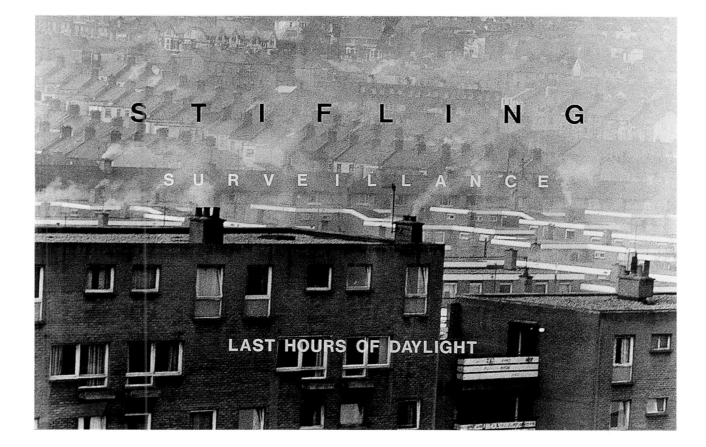

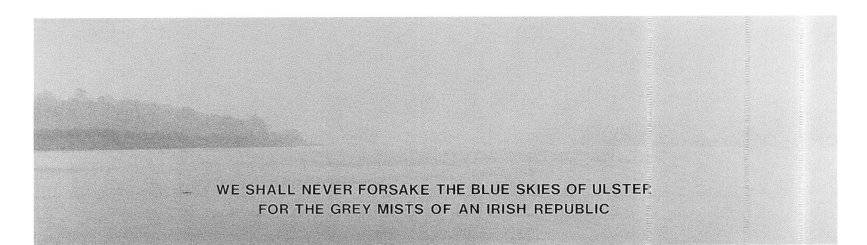

WE SHALL NEVER FORSAKE THE BLUE SKIES OF ULSTER
FOR THE GREY MISTS OF AN IRISH REPUBLIC

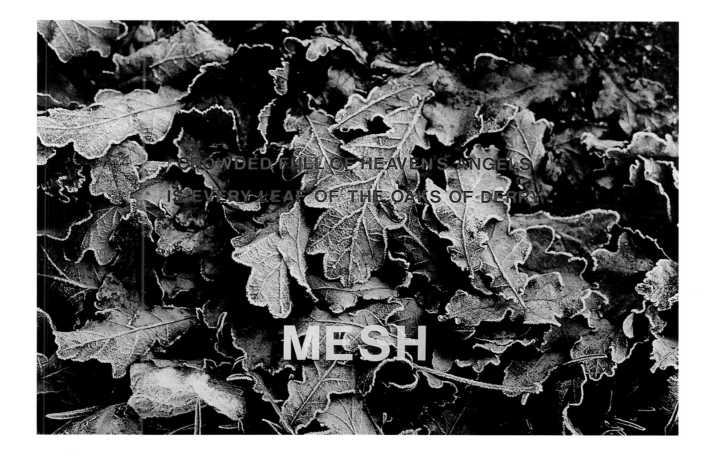

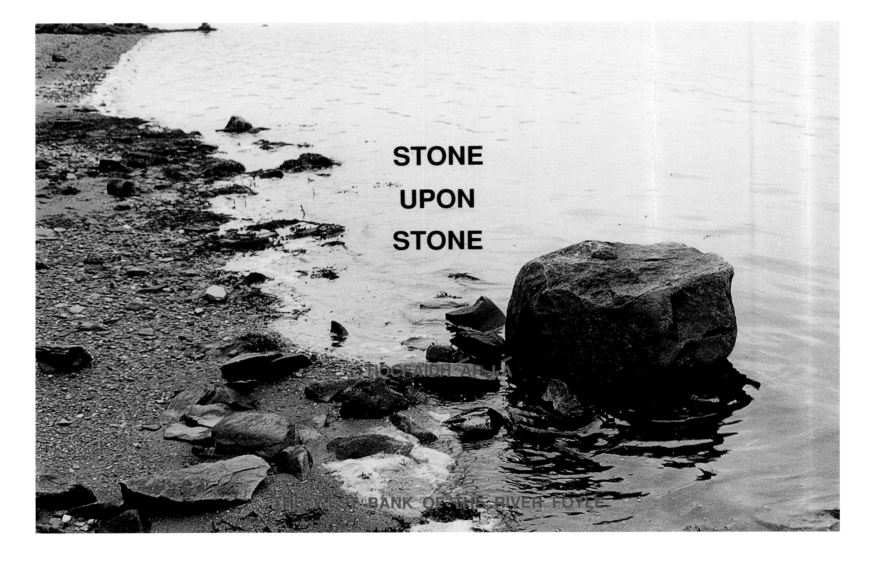

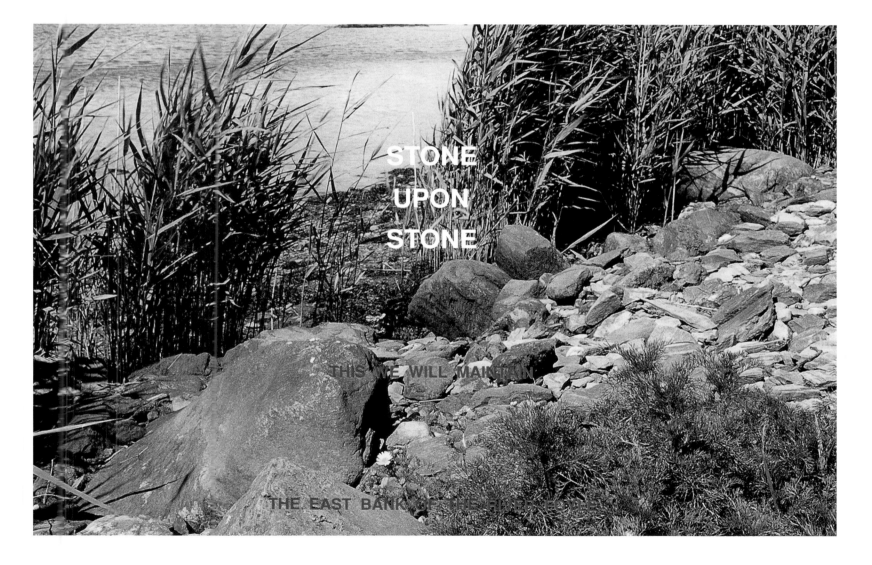

STONE
UPON
STONE

THIS WE WILL MAINTAIN

THE EAST BANK OF THE RIVER FOYLE

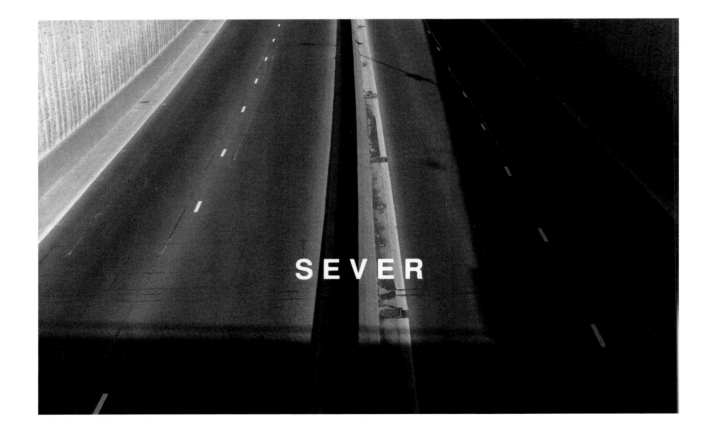

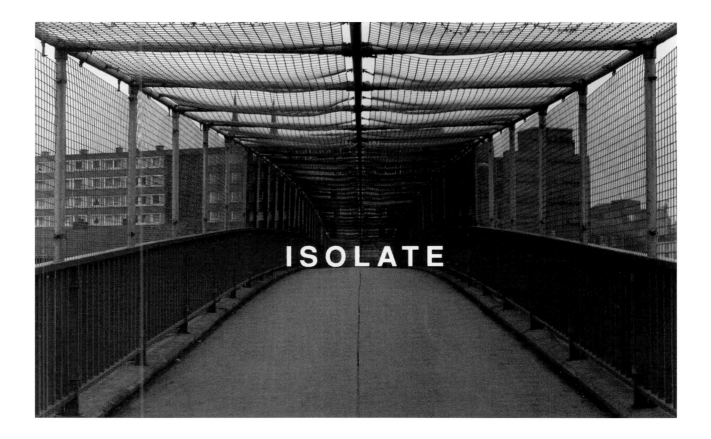

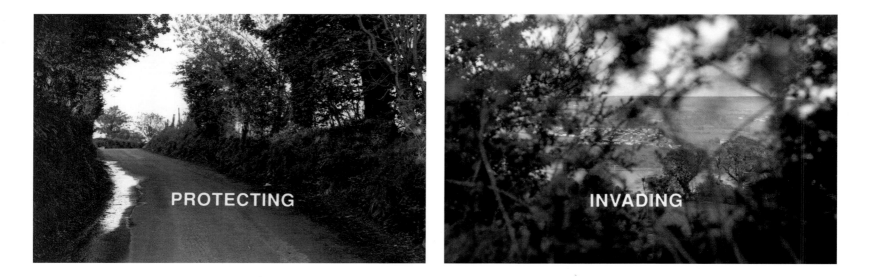

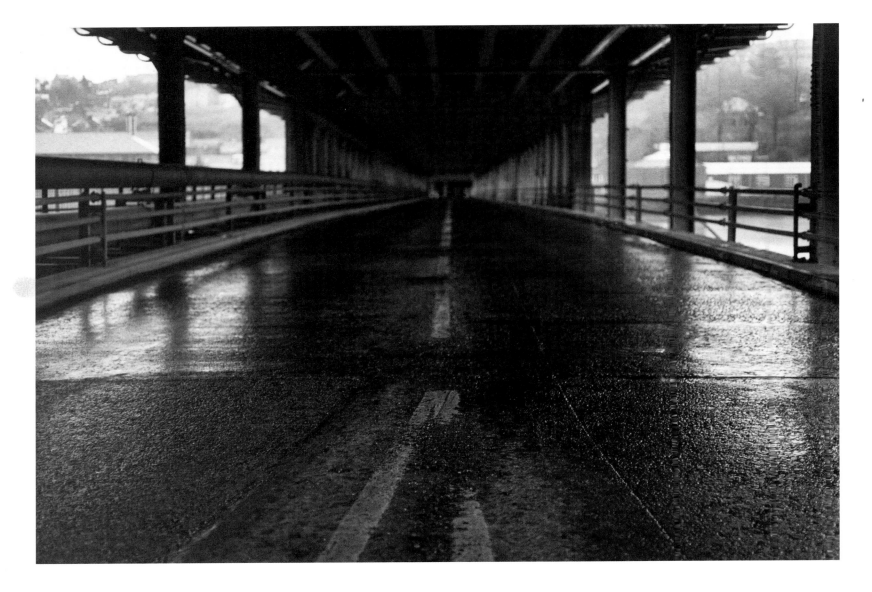

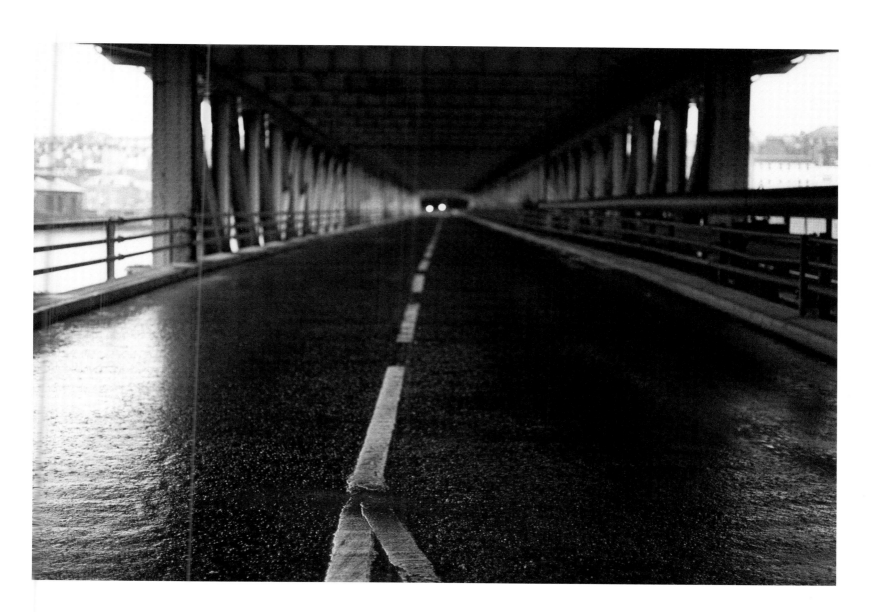

AT THE BORDER I (WALKING TOWARDS A MILITARY CHECKPOINT), 1995 AT THE BORDER II (LOW VISIBILITY), 1995

MINOR INCIDENT I, II, 1994

MINOR INCIDENT III, IV, 1996

PAGES 128–29: WINDSCREEN FRAGMENT, 1996

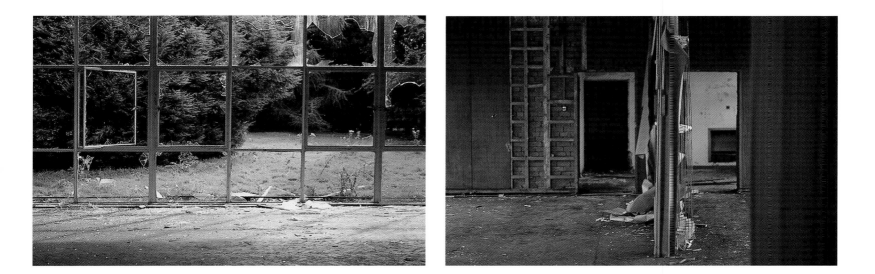

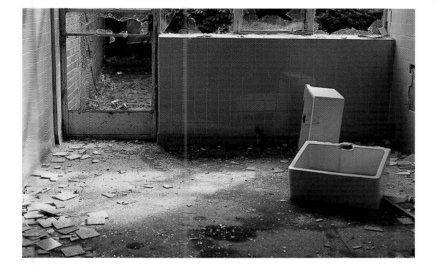

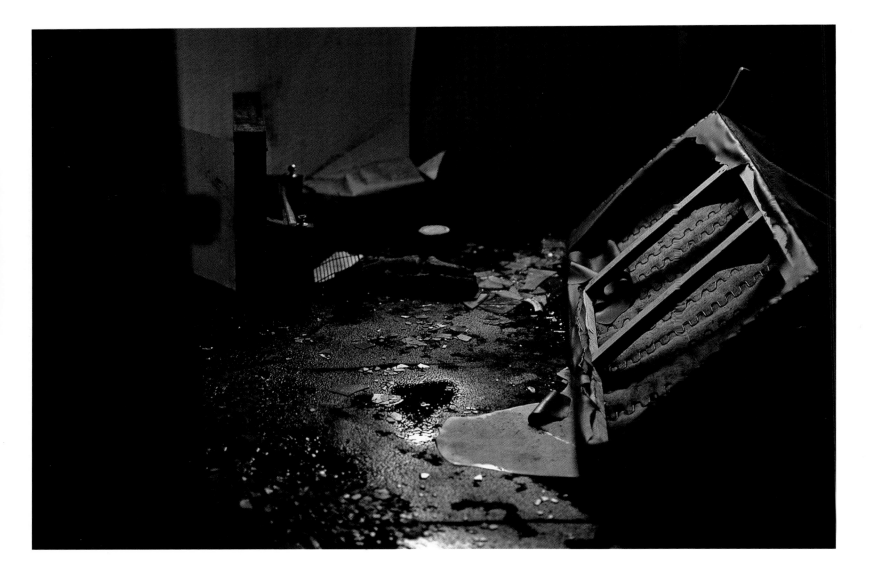

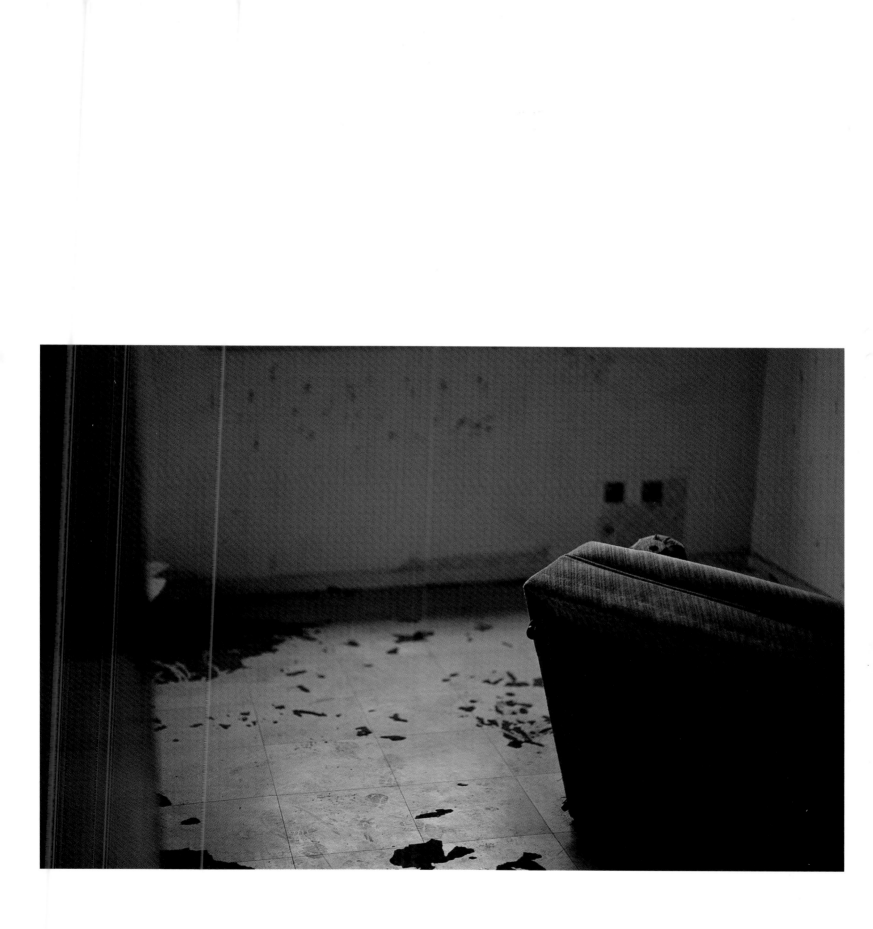

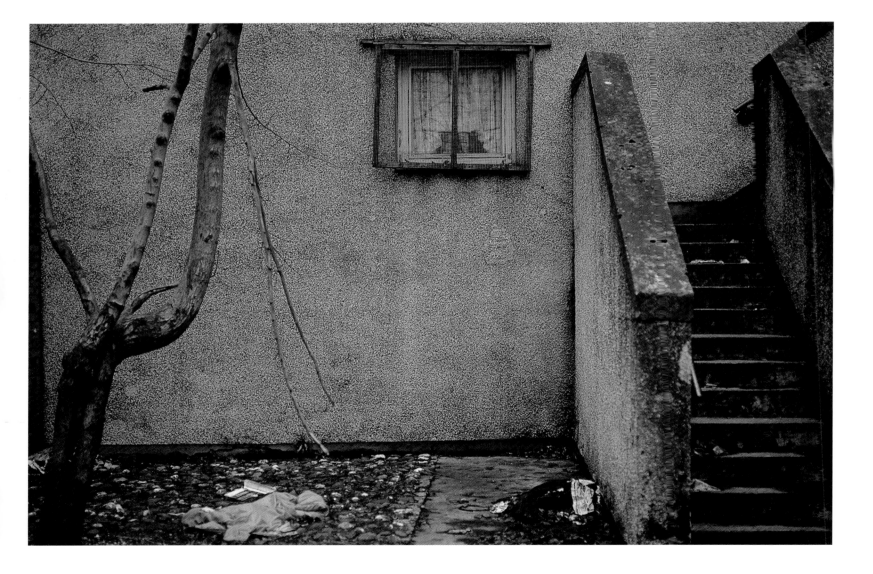

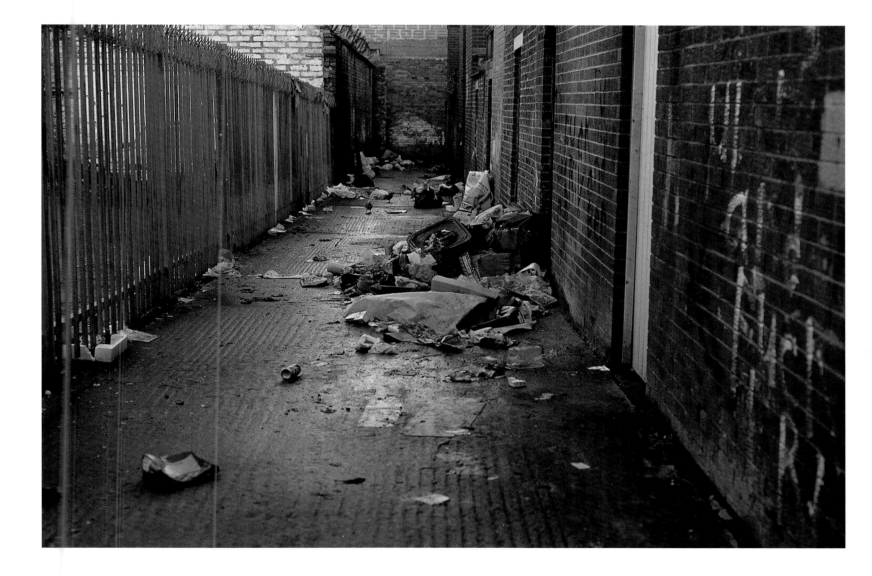

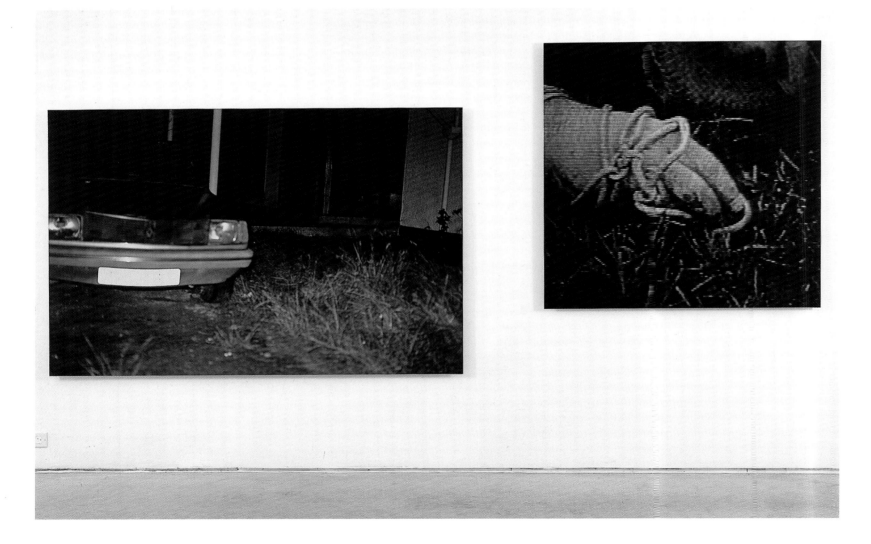

CONTEMPLATING THE CONSEQUENCES OF POLITICAL FAILURE

(THE UNIDENTIFIED MAN SCENE) (DIPTYCH), 1998

CONTEMPLATING THE CONSEQUENCES OF POLITICAL FAILURE

(THE STAKEOUT SCENE) (DIPTYCH), 1998

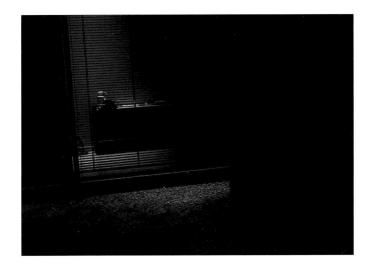

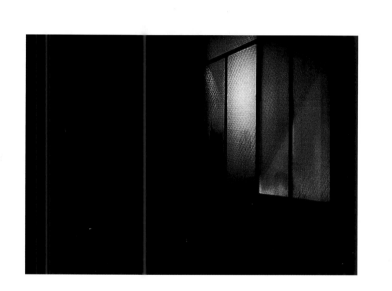

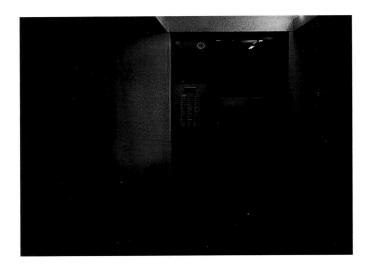

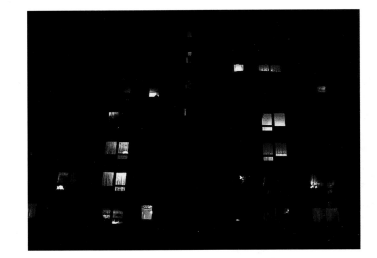

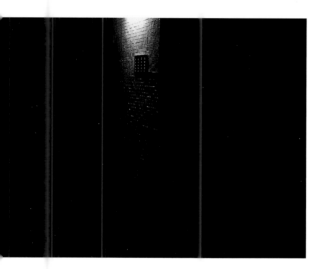

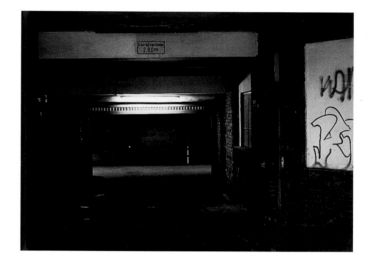

CHECKLIST
OF WORKS

INSTALLATIONS

SAME DIFFERENCE, 1990
Slide installation with four projections on to two diagonally opposite corner walls (black and white). Unique.
First shown Matt's Gallery, London, 1990
Collection Arts Council of England, Hayward Gallery, London

The face of a woman photographed from a television news broadcast is projected on to two diagonally opposite walls of a dark space. Two very different sequences of words are projected on to each face. Each sequence contains a number of identical words ensuring the possibility that at some point the same words are superimposed over each face simultaneously.

Demonstrating on the one hand that our projection of character on to a photograph of a face is heavily dependent upon the way in which language is used to contextualize that face, *Same Difference* also addresses the more unsettling question of how political positions are formed when censorship further limits the possibility of what can be known. The sequence is repeated continuously.

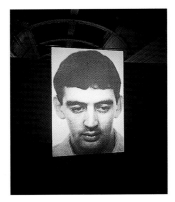

THEY'RE ALL THE SAME, 1991
Slide installation with one projection on to a wooden construction in a dark space (colour, sound, three minutes). Unique.
First shown Hatton Art Gallery, Newcastle upon Tyne, 1991
Courtesy Goetz Collection, Munich

They're All the Same consists of a 35 mm slide projection and an accompanying audio track. The projection is of the face of a young man who appears introspective, with his eyes cast downwards. The image of the man is photographed from a newspaper; the dots of the colour-separation process are visible on the surface. The voice-over is spoken by a young man with a soft Irish accent.

The spoken monologue presents a dual structure as the narrator speaks about the landscape, which is described as an extension of his character, innately wild and untameable. The text also speculates about the concept of an undivided, mythic nation/wilderness as the force that motivates him. In the end, the voice is ridden with self-doubt as it struggles to present both 'selves' ("I am decent and truthful" ... "I am uncivilized and uneducated"). The sequence is repeated continuously.

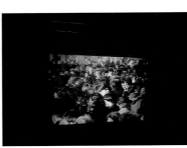

30TH JANUARY 1972, 1993
Slide installation with two projections on one screen (sound, four minutes). Unique.
First shown Douglas Hyde Gallery, Dublin, 1993

Two slides are projected back to back on to a freestanding screen; one shows a crowd scene rephotographed from original television news footage of Bloody Sunday, and the other shows a view of Glenfada Park (one of the locations of the fatal shootings) as it looked in August 1993.

These projections are accompanied by three separate audio tracks played simultaneously in the space; one is sampled from sound recorded during the shooting on Bloody Sunday, and the other two are edited extracts of interviews with passers-by made on Rossville Street (another location of the fatal shootings) in August 1993 by the artist. During the interviews members of the public were asked to respond to the following question: "If you were present during the Bloody Sunday March, can you describe your experience of events, or if you were not present, can you describe a televised or photographic image of Bloody Sunday?"

30th January 1972 was not intended as a contribution to the body of documentary evidence such as existed in 1992, but rather as an attempt to investigate the impact of such a traumatic event on private and public memory and identity.

THE ONLY GOOD ONE IS A DEAD ONE, 1993
Video installation with projection on two walls (colour, sound, thirty minutes). Unique.
First shown Matt's Gallery, London, 1993
Collection Irish Museum of Modern Art, Dublin. On loan from the Weltkunst Foundation

The Only Good One is a Dead One consists of two separate projections, which are shown simultaneously on two opposite walls of a dark space. The first image is a point-of-view shot from the interior of a car travelling along a dark country road at night. Only the car headlights illuminate the scene, and the audio track is the sound of the car as it drives continuously. The second image is a point-of-view shot from the interior of a stationary car on an urban street at night. The scene is illuminated by the red glow of street lamps. Both sequences are recorded in one take and shown unedited.

After a few moments the voice of a young man is heard as he speaks a monologue that seems to refer to both sequences. He describes his fear of being assassinated and his desire for revenge as he plots to ambush another person. The soundtrack of the man speaking is shorter than the two video sequences and overlaps to create a layering of imagery and words as the viewer is forced to move between two distinct but mutually dependent experiences.

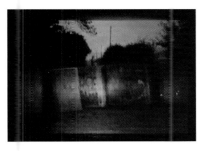

AT THE END OF THE DAY, 1994
Video installation with single projection on one wall (colour, sound, ten minutes). Unique.
First shown The British School at Rome, 1994
Collection Arts Council of England, Hayward Gallery, London

At the End of the Day consists of a short video sequence shot through the windscreen of a car as it travels along a small country road towards an unapproved border crossing. It is almost dark and the sky is tinged red with the last moments of daylight. As the car progresses along the road it suddenly comes to a row of concrete bollards. This border road block forces the car to come to a stop and as the car pauses the sound of the engine is interrupted by a voice that speaks a short phrase. At this point the sequence starts again and finishes at the same point as before with a different phrase.

NO SMOKE WITHOUT FIRE, 1994
Video installation with single projection on one wall (colour, sound, ten minutes). Unique.
First shown Cocido y Crudo, Museo Nacional Centro de Arte Reina Sofia, Madrid, 1994

No Smoke without Fire is filmed at night on a patch of waste ground on the outskirts of the city. Only a lamp on the camera, which moves erratically through grass and rubble, lights the scene. The sequence is edited to create a confusing and discontinuous journey, as the camera picks out discarded articles of clothing and unidentifiable objects. The camera is constantly looking down at the ground, except for a few seconds when it tilts up to show a wire fence, suggesting the possibility of entrapment. The sequence repeats continuously.

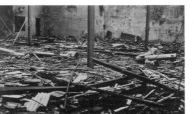

FACTORY (RECONSTRUCTION), 1995
Video installation on one monitor (colour, sound, nine minutes).
First shown Kerlin Gallery, Dublin, 1995

A monitor is located on a shelf in a small space adjacent to a group of related photographs (1994–95). It fades up to a static shot of the devastated interior of a derelict factory. The sound of someone dragging metal is audible from somewhere out of shot. After several minutes a male figure enters from the left. He moves large pieces of debris and rubble and appears to be attempting to create some sense of order. He continues with this apparently impossible task until he finally moves out of frame. The sound of his effort is still audible as the screen fades. The sequence is repeated continuously.

FACTORY (RECONSTRUCTION) 1994
Cibachrome photograph
122 x 183 cm (48 x 72 in.)

FACTORY, 1994
Cibachrome photograph
122 x 183 cm (48 x 72 in.)

FACTORY (AGAINST THE WALL), 1995
Cibachrome photograph
122 x 183 cm (48 x 72 in.)

THE WRONG PLACE, 1996
Video installation with projection on one wall (colour, sound, ten minutes). Unique.
First shown Musée d'Art Moderne de la Ville de Paris, Paris, 1996

The Wrong Place starts in darkness, which is abruptly ended by the sound of a light being switched on. A humming fluorescent light, seen from below, flickers into life. Almost at once this scene cuts to a close-up point-of-view shot as the camera moves down a flight of stairs and starts a disorientating and frightening journey through an old, dysfunctional and abandoned building.

This unknown place is lit solely by a lamp on the camera, which illuminates only the immediate area, revealing details of the interior and signs of use such as cigarette butts, discarded clothing and other traces that evoke the idea of a hideout or refuge. The only sound is the noise of footsteps, the constant loud humming of the fluorescent light from the adjacent staircase and other ambient noises from the dark space.

This search is suddenly ended with the sound of running footsteps as the camera moves frantically as if trying to escape. The sequence ends back at the top of

the stairs, where we are plunged back into darkness, hearing only the sound of panting and heavy breathing. Suddenly the light flickers on again, and the camera starts a similar journey through the same space. Again this sequence ends back at the same place, and the first sequence repeats.

TELL ME WHAT YOU WANT, 1996
Installation on two monitors positioned to face each other (colour, sound, ten minutes).
First shown Galleria Emi Fontana, Milan, 1996

Two different images fade up simultaneously on two monitors. One is a close-up of a road surface at night. It is raining heavily, and a street lamp, which casts a red light over the scene, lights the road. This is accompanied by the sound of heavy rainfall and howling wind. The other monitor shows a detail of a country roadside and a grass verge. It is daytime and the scene is accompanied by the sounds of birds singing and the occasional rumble of distant traffic.

Both monitors fade down and after a few seconds fade up with two different images. One is a mug shot of a man, backlit and in silhouette. The other is a woman's head similarly backlit and in silhouette. They both speak a short piece of dialogue, which sounds as if it could be part of a script or a snippet of a confessional interview. The screens fade back to the opening scenes. This pattern is repeated but occasionally interrupted, when they speak at different times and sometimes say the same piece of dialogue. The sequence repeats continuously.

SAME OLD STORY, 1997
Video installation with projection on two screens (colour, sound, ten minutes). Unique.
First shown Matt's Gallery, London, 1997

Same Old Story consists of two distinct yet parallel video sequences. Both are projected simultaneously on to two freestanding screens, positioned diagonally opposite each other. The work positions the viewer in the middle of a cyclical and diffuse excursion through the physical motifs of a scarred urban landscape. The camera traverses bridges, surveys derelict interiors and investigates the fringes of green spaces. Occasionally fleeting glimpses of a figure are provided, but his identity and intention remain ambiguous.

Same Old Story frustrates the viewer's expectations of any narrative potential by highlighting mechanisms of projection and identification. Shifts between hand-held camcorder and steady-cam footage and the use of long static shots of the city alongside intensely slow tracking shots interrupt the conventions of mainstream visual narrative. Both sequences repeat continuously.

BLACKSPOT, 1997
Video installation with single projection on one wall (colour, thirty minutes).
First shown Galerie Peter Kilchmann, Zurich, 1997

Blackspot is a single-channel video installation projected directly on to the wall of a small dark space. *Blackspot* shows a street scene gradually getting darker as night falls, and is unedited and projected in real time. The footage is shot from the vantage point of the City Walls, which overlook the Catholic Bogside area of Derry. The camera position refers to both the historical function of the defensive ramparts of the Walls and to the surveillance cameras of the British Army that occupy the same contested space. The sequence is repeated continuously.

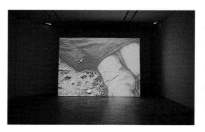

SOMETIMES I IMAGINE IT'S MY TURN, 1998
Video installation with projection on one screen (colour, sound, three minutes).
First shown Angles Gallery, Los Angeles, 1998

Sometimes I Imagine it's My Turn starts as the camera pans slowly across a stretch of waste ground and unexpectedly comes upon a figure lying face down on the ground. This establishing shot is quickly followed by a sequence of tracking shots that take us closer and closer to the figure, whose identity is never disclosed. The continuity of this sequence is interrupted by close-up shots of the undergrowth and by short inserts of hand-held footage of the same scene. The growing sense of unease is further heightened by the intrusion of rapid inserts of television footage, suggesting a link between the subject of the video and actual news coverage. The overall sequence is accompanied by the distant sound of a helicopter and ends abruptly in a flash of white noise, only to repeat again and again.

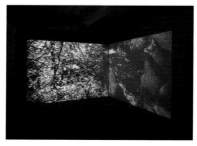

SOMEWHERE ELSE, 1998
Video installation with projection on four screens (colour, sound, ten minutes). Unique.
First shown Tate Gallery, Liverpool, 1998
Collection The Carnegie Museum of Art, Pittsburgh, Pennsylvania

Somewhere Else consists of four synchronized video sequences, which are projected simultaneously on to an X-shaped configuration of four rear-projection screens. A separate soundtrack accompanies each video sequence, and the speakers for each are fixed to the wall opposite each screen, at head height.

The footage for this work was shot in urban and rural locations in Derry and Donegal. The edited sequences move easily between apparently tranquil rural settings and the unsettling dead spaces of the city. The accompanying voice-over monologue appears to attempt to make sense of a "straightforward story with a twist". However, the 'story' is punctuated by references to the production of the video: "Fade up to a scene in a forest", "The camera follows him from behind." The multiple viewpoints and shifts between locations, and an inability to fix the role of the narrator, reinforce the impossibility of resolution or closure. The sequences repeat continuously.

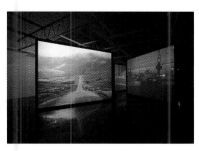

TRUE NATURE, 1999
Video installation with projection on five screens (colour, sound, ten minutes). Unique.
First shown Renaissance Society, Chicago, 1999
Collection Solomon R. Guggenheim Museum, New York. Partial and promised gift, The Bohen Foundation, New York, 2001

True Nature consists of five separate but related video sequences, which are shown simultaneously. The videos are projected on to five freestanding screens made with rear-projection material, allowing the image to be viewed from both sides. The screens are installed in a configuration whereby they stand at various angles to one another, enabling the viewer to see more than one sequence at any time and to move freely between the screens. A soundtrack accompanies each video sequence and the speakers are fixed to the wall at head height near each screen.

The video footage and audio material for *True Nature* was recorded in Chicago in August and November 1998 and in Ireland in January 1999. The Chicago video footage was recorded in the downtown area, in neighbourhoods that were identified to the artist as 'Irish' and on public transport to and from these areas and the International Airport. At the same time the artist conducted a number of interviews with members of the Irish-American community. The criteria for the interviewees were that they should be second-or third-generation Irish and that they should never have visited Ireland. The interviews concentrated on their views and perceptions of Ireland and how these impressions were shaped through family stories, news coverage, cinema and so on. The video footage recorded in Ireland was shot in response to the Chicago interviews and attempted to 'find' some of the places and types of landscape described in them.

Each video sequence is compiled from this material in a non-linear and fragmentary manner whereby images, ambient sounds and voices are juxtaposed. The sequence is repeated continuously.

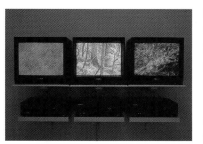

RESTRICTED ACCESS, 1999
Video installation on three monitors (colour, nine minutes).
First shown Alexander and Bonin, New York, 1999

Restricted Access is an installation of three monitors, which are installed simply in a horizontal line on a wall of a small space, adjacent to a group of related photographs. Each monitor shows a different, detailed view of a dense wood located close to the Derry–Donegal border. Initially each image appears to be static, but on closer inspection small shifts in the image are perceptible. Each section is edited from a much longer sequence to create a time-lapse effect. Consequently real time is collapsed as the camera pans slowly across the undergrowth or remains static on the same scene. The three sequences rotate in turn every three minutes on each monitor, imitating the shifting viewpoints of a row of surveillance monitors. The sequences repeat continuously.

RESTRICTED ACCESS (BENEATH THE SURFACE I), 1999
Cibachrome photograph
122 x 122 cm (48 x 48 in.)

RESTRICTED ACCESS (BENEATH THE SURFACE II), 1999
Cibachrome photograph
122 x 122 cm (48 x 48 in.)

RESTRICTED ACCESS (OFF THE PATH), 1999
Cibachrome photograph
122 x 183 cm (48 x 72 in.)

CONTROL ZONE, 1999
Video installation with single projection on one wall (colour, thirty minutes).
First shown Koldo Mitxelena Kulturunea, Donostia-San Sebastián, 1999

Control Zone is a thirty-minute video that plays in real time. The sequence is filmed from a distant vantage point above the Craigavon Bridge, which separates the mainly Loyalist community on the east bank and the mainly Catholic community on the west bank of the River Foyle in Derry. The camera is directly in line with the bridge so that the vehicles appear locked into a vertical movement up and down the viewing screen. This effect is enhanced by the use of a powerful telephoto lens that compresses our perception of space. The sequence is repeated continuously.

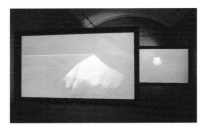

HOW IT WAS, 2001
Video installation with projection
on two screens (colour, sound, seven
minutes). Unique.
First shown Ormeau Baths Gallery,
Belfast, 2001

How it Was consists of two synchronized 16:9 widescreen video sequences,
projected simultaneously on to two freestanding screens. The screens are made
with rear-projection material, allowing the image to be viewed from both
sides. Each screen is fixed at one edge to opposite walls of a dark space,
so that the screen extends out into the space. This configuration enables the
viewer to walk through the space and around both sides of the screens.
Four speakers are installed in the four corners of the space.

The footage for this work was shot in an abandoned car mechanic's garage.
The garage was discovered with all the tools and fixtures intact and was not
altered in any way for the making of this work. One female and two male
actors appear in both video sequences. They appear fleetingly in the garage
and seem to be engaged in some unspecified activity. The same scenes are shot
with all three actors, and in the final edit their appearances are juxtaposed
and interchanged. A soundtrack, featuring three voices, which repeat the same
short phrases, accompanies both sequences. These observations or accounts
appear to describe both the garage and the activities we have been watching
as past events. However, some doubt remains as to whether these are the
voices of the people we see on the screen or some other eyewitnesses.

Both video sequences are composed of the same series of shots, but these are
shown in reverse order in both cases. Thus, the start of one sequence is the end
of the other but there is a point in the middle where the same image appears
briefly on both screens. The sequences repeat continuously. A group of related
photographs is shown in an adjoining space.

I WAS THERE AND I HAVE DOUBTS (THE DRAWER) 2001
Digital photograph
76 x 101.5 cm (30 x 40 in.)

I WAS THERE AND I HAVE DOUBTS (THE WAY OUT) 2001
Digital photograph
114 x 152 cm (45 x 60 in.)

I WAS THERE AND I HAVE DOUBTS (THE EDGE) 2001
Digital photograph
114 x 152 cm (45 x 60 in.)

I WAS THERE AND I HAVE DOUBTS (THE PIT) 2001
Digital photograph
76 x 101.5 cm (30 x 40 in.)

RETRACES, 2002
Video installation on seven monitors
(colour, fifteen minutes).
First shown Matt's Gallery, London,
2002

Retraces is an installation of seven
separate but related video sequences, shown simultaneously on seven 69 cm
(27 in.) colour monitors. The monitors are displayed along one wall approx-
imately twelve metres long, and installed at varying heights along the wall.

All the footage is shot using a static camera position. The camera does not tilt,
pan or shift, zoom or focus. The footage is shot in a number of urban locations in
Derry and Belfast and in various rural location along the Derry–Donegal border.
The work is edited so that variations of the same shots appear on different
screens simultaneously and at separate moments throughout the entire duration
of all seven sequences. These shots may vary in duration, but also in speed, as
some have been slowed down or speeded up. In general, each sequence alternates
between scenes shot at night or day and in the city or the countryside.

At various points during each sequence a short text referring to a specific
date, time or place, for example *Belfast, 1998* appears as a subtitle. This
device echoes the convention used within fiction and documentary film to
locate and shift the story/plot within space and time. These dates refer both
to the actual places depicted but also to a more general understanding of how
we describe our individual experiences and activities through a series of dates
The sequences are repeated continuously.

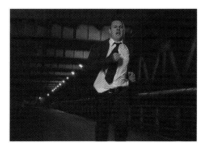

RE-RUN, 2002
Video installation with projection on
two screens (colour, thirty seconds).
Unique.
First shown XXV Bienal de São
Paulo, São Paulo, Brazil, 2002

Re-Run consists of two short video
sequences showing a male figure running across a bridge at night. Each video
lasts thirty seconds but is seamlessly looped to create an extended sequence.
Both are projected simultaneously on to freestanding screens. The screens are
positioned directly facing each other at opposite ends of a dark space.

Each sequence is compiled from multiple takes of the same figure running
across the bridge in wide-shot, mid-shot or close-up. This material is edited
to make a short, fast sequence of approximately forty-two separate cuts. The
figure is permanently running in the middle of the bridge. He never reaches his
destination, caught in the act of running continuously. One sequence depicts
the man running towards the camera, which is moving away from him, at the
same speed. The other sequence shows the man running away from the camera
which is moving after him, keeping him constantly within the frame. Both
sequences are repeated continuously.

PHOTOGRAPHS

FIG: ICE/LAST HOURS OF DAYLIGHT, 1985
Black-and-white photographs with text
Diptych: each panel 122 x 183 cm (48 x 72 in.)

THE BLUE SKIES OF ULSTER, 1986
Black-and-white photograph with text
152 x 46 cm (60 x 18 in.)
Unique
Private collection, Dublin

MESH, 1986
Black-and-white photograph with text
61 x 91 cm (24 x 36 in.)
Unique
Collection Contemporary Irish Arts Society/Irish
Hospice Foundation

STONE UPON STONE, 1986
Black-and-white photographs with text
Diptych: each panel 122 x 183 cm (48 x 72 in.)
Unique

THE WALLS, 1987
Black-and-white photograph with text
61 x 152.5 cm (24 x 60 in.)
Unique

THE OTHER SIDE, 1988
Black-and-white photograph with text
61 x 152 cm (24 x 60 in.)

STRATEGY: SEVER/ISOLATE, 1989
Black-and-white photographs with text
Diptych: each panel 122 x 183 cm (48 x 72 in.)

PROTECTING/INVADING, 1987
Black-and-white photographs with text
Diptych: each panel 122 x 183 cm (48 x 72 in.)

ENDURING, 1992
Black-and-white photograph with text
122 x 183 cm (48 x 72 in.)

GOD HAS NOT FAILED US (THE FOUNTAIN,
DERRY), 1990
Black-and-white photograph with text
122 x 183 cm (48 x 72 in.)

SHIFTING GROUND (THE WALLS, DERRY), 1991
Black-and-white photograph with text
122 x 183 cm (48 x 72 in.)

NATIVE DISORDERS I, 1991
C-type colour photograph with text
114 x 152 cm (45 x 60 in.)

NATIVE DISORDERS III, 1991
C-type colour photograph with text
114 x 152 cm (45 x 60 in.)

THE BRIDGE, 1992
Black-and-white photographs
Diptych: each panel 122 x 183 cm (48 x 72 in.)

UNAPPROVED ROAD, 1992
Black-and-white photograph
122 x 183 cm (48 x 72 in.)

ALLEYWAY, 1992
Black-and-white photograph
122 x 183 cm (48 x 72 in.)

INCIDENT, 1993
Cibachrome photograph
122 x 183 cm (48 x 72 in.)

BORDER INCIDENT, 1994
Cibachrome photograph
122 x 183 cm (48 x 72 in.)

BORDER ROAD, 1994
Cibachrome photograph
122 x 183 cm (48 x 72 in.)

BLOCKED ROAD, 1994
Cibachrome photographs
Diptych: each panel 122 x 183 cm
(48 x 72 in.)

BORDER ROAD II, 1994
Cibachrome photograph
122 x 183 cm (48 x 72 in.)

THE OUTSKIRTS, 1994
Cibachrome photograph
122 x 183 cm (48 x 72 in.)

AT THE BORDER I (WALKING TOWARDS A
MILITARY CHECKPOINT), 1995
Cibachrome photograph
122 x 183 cm (48 x 72 in.)

AT THE BORDER II (LOW VISIBILITY), 1995
Cibachrome photograph
122 x 183 cm (48 x 72 in.)

AT THE BORDER III (TRYING TO FORGET
THE PAST), 1995
Cibachrome photograph
122 x 183 cm (48 x 72 in.)

AT THE BORDER IV (THE INVISIBLE LINE), 1995
Cibachrome photograph
122 x 183 cm (48 x 72 in.)

MINOR INCIDENT I, 1994
Cibachrome photograph
76 x 101.5 cm (30 x 40 in.)

MINOR INCIDENT II, 1994
Cibachrome photograph
76 x 101.5 cm (30 x 40 in.)

MINOR INCIDENT III, 1996
Cibachrome photograph
76 x 101.5 cm (30 x 40 in.)

MINOR INCIDENT IV, 1996
Cibachrome photograph
76 x 101.5 cm (30 x 40 in.)

BULLET HOLES, 1995
Cibachrome photograph
76 x 101.5 cm (30 x 40 in.)

DISCARDED NUMBER PLATE, 1996
Cibachrome photograph
76 x 101.5 cm (30 x 40 in.)

UNCOVERING EVIDENCE THAT THE WAR IS
NOT OVER I, 1995
Cibachrome photograph
76 x 101.5 cm (30 x 40 in.)

UNCOVERING EVIDENCE THAT THE WAR IS
NOT OVER II, 1995
Cibachrome photograph
76 x 101.5 cm (30 x 40 in.)

WINDSCREEN FRAGMENT, 1996
Cibachrome photograph
76 x 101.5 cm (30 x 40 in.)

DISCLOSURE I (RESTRICTED ACCESS), 1996
Cibachrome photograph
122 x 183 cm (48 x 72 in.)

DISCLOSURE II (INVISIBLE TRACES), 1996
Cibachrome photograph
122 x 183 cm (48 x 72 in.)

DISCLOSURE III (SUPERFICIAL SCRATCHES),
1996
Cibachrome photograph
122 x 183 cm (48 x 72 in.)

THE FENCE, 1996
Cibachrome photograph
122 x 183 cm (48 x 72 in.)

NO VISIBLE SIGNS, 1997
Cibachrome photograph
122 x 183 cm (48 x 72 in.)

OUT OF SIGHT, 1997
Cibachrome photograph
122 x 183 cm (48 x 72 in.)

CRITICAL DISTANCE, 1997
Cibachrome photograph
122 x 183 cm (48 x 72 in.)

LOOKING BACK, 1997
Cibachrome photograph
122 x 183 cm (48 x 72 in.)

THE ROAD AHEAD, 1997
Cibachrome photograph
122 x 183 cm (48 x 72 in.)

ABANDONED INTERIOR II, 1997
Cibachrome photograph
122 x 183 cm (48 x 72 in.)

ABANDONED INTERIOR III, 1997
Cibachrome photograph
122 x 183 cm (48 x 72 in.)

LAST OCCUPANT, 1997
Cibachrome photograph
122 x 183 cm (48 x 72 in.)

DARK STAINS, 1997
Cibachrome photograph
122 x 183 cm (48 x 72 in.)

OUT OF THE SHADOWS, 1997
Cibachrome photograph
122 x 183 cm (48 x 72 in.)

SEARCHING, 1997
Cibachrome photograph
122 x 183 cm (48 x 72 in.)

SMALL ACTS OF DECEPTION II, 1997
Cibachrome photographs
Diptych: each panel 122 x 183 cm (48 x 72 in.),
122 x 122 cm (48 x 48 in.)

SMALL ACTS OF DECEPTION I, 1997
Cibachrome photographs
Diptych: each panel 122 x 183 cm (48 x 72 in.),
122 x 122 cm (48 x 48 in.)

CONTEMPLATING THE CONSEQUENCES OF
POLITICAL FAILURE (THE UNIDENTIFIED
MAN SCENE), 1998
Cibachrome photographs
Diptych: each panel 76 x 101.5 cm (30 x 40 in.)

CONTEMPLATING THE CONSEQUENCES OF
POLITICAL FAILURE (THE STAKEOUT SCENE),
1998
Cibachrome photographs
Diptych: each panel 76 x 101.5 cm (30 x 40 in.)

EXTRACTS FROM A FILE, 2000
Set of forty black-and-white photographs:
each panel 45 x 60 cm (17 3/4 x 23 1/2 in.)

RETRACES I, 2002
Digital photograph
114 x 152 cm (45 x 60 in.)

RETRACES II, 2002
Digital photograph
114 x 152 cm (45 x 60 in.)

RETRACES III, 20 2
Digital photograph
114 x 152 cm (45 x 60 in.)

RETRACES IV, 20 2
Digital photograph
114 x 152 cm (45 x 60 in.)

All works courtesy Willie Doherty; Alexander and
Bonin, New York; and Matt's Gallery, London

WILLIE DOHERTY

The artist lives and works in Derry, Northern Ireland

AWARDS AND RESIDENCIES

1999 DAAD Grant – International Artists' Programme, Berlin
1995 Winner of Irish Museum of Modern Art, Glen Dimplex Artists'
 Award, Dublin
1994 Short-listed for the Turner Prize, Tate Gallery, London

ONE-PERSON EXHIBITIONS

2002 *Willie Doherty*, Kerlin Gallery, Dublin
 Willie Doherty: False Memory, Irish Museum of Modern Art,
 Dublin, mid-career retrospective (catalogue)
 Willie Doherty: Retraces, Matt's Gallery, London
2001 *Willie Doherty: Double Take*, Ormeau Baths Gallery, Belfast
 (catalogue)
 Extracts from a File, Alexander and Bonin, New York
2000 *Extracts from a File*, Gesellschaft für Aktuelle Kunst, Bremen
 Extracts from a File, Galerie Peter Kilchmann, Zurich
 Extracts from a File, DAAD Galerie, Berlin (catalogue)
 Extracts from a File, Kerlin Gallery, Dublin
1999 *Dark Stains*, Koldo Mitxelena Kulturunea, Donostia-San Sebastián
 (catalogue)
 Willie Doherty: New Photographs and Video, Alexander and Bonin,
 New York
 Same Old Story, Firstsite, Colchester
 True Nature, The Renaissance Society, Chicago
 Somewhere Else, Museum of Modern Art, Oxford
1998 *Somewhere Else*, Tate Gallery, Liverpool (catalogue)
 Willie Doherty, Galerie Jennifer Flay, Paris
 Willie Doherty, Galleria Emi Fontana, Milan
 Willie Doherty, Angles Gallery, Los Angeles
1997 *Willie Doherty: Same Old Story*, Matt's Gallery, London; Orchard
 Gallery, Derry; Berwick Gymnasium, Berwick-upon-Tweed;
 Le Magasin, Grenoble (catalogue)
 Willie Doherty, Galerie Peter Kilchmann, Zurich
 Willie Doherty, Kerlin Gallery, Dublin
 Blackspot, Firstsite, Colchester (catalogue)
1996 *Willie Doherty: The Only Good One is a Dead One*, Edmonton Art
 Gallery, Edmonton; Mendel Art Gallery, Saskatoon; Art Gallery of
 Windsor, Windsor; Art Gallery of Ontario, Toronto (1997); Fundação
 Calouste Gulbenkian, Lisbon (catalogue)
 Tell Me What You Want, Galleria Emi Fontana, Milan
 Willie Doherty, Alexander and Bonin, New York
 Willie Doherty, Musée d'Art Moderne de la Ville de Paris, Paris
 (catalogue)
 In the Dark: Projected Works by Willie Doherty, Kunsthalle, Bern;

Kunstverein, Munich (catalogue)
1995 *Willie Doherty*, Kerlin Gallery, Dublin
 Willie Doherty, Galerie Jennifer Flay, Paris
 Willie Doherty, Galerie Peter Kilchmann, Zurich
1994 *At the End of the Day*, British School at Rome (brochure)
 The Only Good One is a Dead One, Arnolfini, Bristol; Grey Art
 Gallery, New York University, New York (catalogue)
1993 *30th January 1972*, Douglas Hyde Gallery, Dublin
 They're All the Same, Centre for Contemporary Art, Ujazdoski
 Castle, Warsaw
 The Only Good One is a Dead One, Matt's Gallery, London
 Willie Doherty, Galerie Jennifer Flay, Paris
1992 *Willie Doherty*, Galerie Peter Kilchmann, Zurich
 Willie Doherty, Oliver Dowling Gallery, Dublin
 Willie Doherty, Tom Cugliani Gallery, New York
1991 *Kunst Europa, Six Irishmen*, Kunstverein, Schwetzingen
 Willie Doherty, Tom Cugliani Gallery, New York
 Willie Doherty, Galerie Giovanna Minelli, Paris
 Unknown Depths, John Hansard Gallery, Southampton; Angel Row
 Gallery, Nottingham; Institute of Contemporary Arts, London;
 Ffotogallery, Cardiff; Third Eye Centre, Glasgow; Orchard Gallery,
 Derry (catalogue)
1990 *Same Difference*, Matt's Gallery, London
 Imagined Truths, Oliver Dowling Gallery, Dublin
1988 *Colourworks*, Oliver Dowling Gallery, Dublin
 Two Photoworks, Third Eye Centre, Glasgow
1987 *The Town of Derry*, *Photoworks*, Art and Research Exchange,
 Belfast
 Photoworks, Oliver Dowling Gallery, Dublin
1986 *Stone upon Stone*, Redemption, Derry
1982 *Siren, an installation*, Art and Research Exchange, Belfast
 Collages, Orchard Gallery, Derry
1980 *Installation*, Orchard Gallery, Derry

GROUP EXHIBITIONS

2002 Selection of work from the XXV Bienal de São Paulo, Museum of
 Contemporary Art, Santiago, Chile
 Willie Doherty, Paul Etienne Lincoln and Rita McBride, group
 show, Alexander and Bonin, New York
 Re-Run, XXV Bienal de São Paulo, São Paulo, Brazil
2001 *Double Vision*, Galerie für Zeitgenössische Kunst, Leipzig (catalogue)
 The Inner State: The Image of Man in the Video Art of the 1990s,
 Kunstmuseum Liechtenstein, Vaduz (catalogue)
 Landscape, British Council international touring exhibition: Centro
 Cultural del Conde Duque, Madrid; Sofia Municipal Gallery of Art;
 Museu de Arte Contemporânes de Niterio, Rio de Janeiro; Museu de
 Arte de São Paulo, Brazil; Le Botanique, Centre Cultural de la
 Communauté française Wallonie-Bruxelles (2002) (catalogue)
 Trauma, National Touring Exhibitions, Hayward Gallery, Dundee

163

Contemporary Arts; Firstsite, Colchester; Museum of Modern Art, Oxford; Museum of Modern Art, Nottingham (catalogue)
(Self) Portraits, Alexander and Bonin, New York
The Uncertain (Eija-Liisa Ahtila, Willie Doherty, Guillermo Kuitca, Taro Sinoda). Galería Pepe Cobo, Seville
Bloody Sunday (Willie Doherty, Locky Morris, Philip Napier), Orchard Gallery, Derry
Gisela Bullacher/Willie Doherty, Produzentengalerie, Hamburg
Night on Earth, Stadt Ausstellungshalle Am Hawerkamp, Munster (catalogue)

2000 *Blackspot: New Acquisitions*, Vancouver Art Gallery, Vancouver
Hitchcock and Art: Fatal Coincidences, Musée des Beaux-Arts de Montréal, Montréal
Shifting Ground: Selected Works of Irish Art 1950–2000, Irish Museum of Modern Art, Dublin (catalogue)
Drive: power>progress>desire, Govett-Brewster Art Gallery, New Plymouth
Landscape, British Council international touring exhibition: ACC Gallery, Weimar; House of Artists, Moscow; Peter + Paul Fortress, St Petersburg; Galleria Nazionale d'Arte Moderna, Rome (catalogue)
Look Out, touring exhibition organized by Art Circuit: Wolverhampton Art Gallery; Bluecoat Gallery, Liverpool; Pitshanger Manor Gallery, London; Wolsey Art Gallery, Christchurch Mansion (catalogue)

1999 *Dimensions Variable*, British Council international touring exhibition: Kunsthalle Darmstadt, Darmstadt; Budapest Museum of Contemporary Art and Ludwig Museum; Slovak National Gallery, Bratislava; National Gallery of Art, Bucharest (catalogue)
Des conflits intérieurs, Willie Doherty and Donovan Wylie, Saison Photographique d'Octeville (catalogue)
Sleuth, Chapter Arts Centre and Ffotogallery, Cardiff; Oriel Mostyn Gallery, Llandudno; Barbican Art Gallery, London
Irish Art Now: From the Poetic to the Political, ICI/IMMA touring show: McMullen Museum of Art, Boston College; Art Gallery of Newfoundland and Labrador (2000); Chicago Cultural Center, Chicago (2001); Irish Museum of Modern Art, Dublin
Expansive Vision: Recent Acquisitions of Photographs in the Dallas Museum of Art, Dallas Museum of Art, Texas
Endzeit Transart, Charim Klocker, Dorotheergasse, Vienna
Insight-Out, Kunstraum Innsbruck, Innsbruck
War Zones, Presentation House Gallery, Vancouver
Contemporary Art, Arts Council Collection, Limerick City Art Gallery, Limerick
Carnegie International, Carnegie Museum of Art, Pittsburgh (catalogues)

1998 *Emotion: Young British and American Art from the Goetz Collection*, Deichtorhalle, Hamburg
Critical Distance, Andrew Mummery, London
New Art from Britain, Kunstraum, Innsbruck (catalogue)
Wounds: Between Democracy and Redemption in Contemporary Art, Moderna Museet, Stockholm

Eugenio Dittborn, Willie Doherty, Mona Hatoum, Doris Salcedo, Alexander and Bonin, New York
Art from the UK (Part II), Sammlung Goetz, Munich
Photographs, Alexander and Bonin, New York
A Sense of Place, Angles Gallery, Los Angeles
Summer Show, Kerlin Gallery, Dublin
Real/Life: New British Art, Tochigi Prefecturial Museum of Fine Arts; Fukoma City Art Museum; Hiroshima City Museum of Contemporary Art; Tokyo Museum of Contemporary Art; Ashiya City Museum of Art and History – Japan (catalogue)
Dimensions Variable, British Council international touring exhibition: Helsinki City Art Museum, Helsinki; Stockholm Royal Academy of Free Arts (in collaboration with IASPIS), Stockholm; SOROS Foundation, Kiev; Gallery Zacheta, Warsaw; Stadtische Kunstsammlungen Chemnitz; Prague National Gallery, Prague; Croatian Union of Artists Gallery, Zagreb (catalogue)

1997 *Pictura Britannica: Art from Britain*, touring exhibition: Museum of Contemporary Art, Sydney; Art Gallery of South Australia, Adelaide; Te Papa, Wellington (catalogue)
Between Lantern and Laser, Henry Art Gallery, Seattle
Identité, Nouveau Musée/Institut – FRAC Rhône-Alpes, Villeurbanne; Stedelijk Van Abbemuseum, Eindhoven (brochure)
Città/Nattura, Palazzo delle Esposizioni, Rome (catalogue)
Islas, Centro Atlantico de Arte Moderno, Las Palmas (catalogue)
New Found Land Scape, Kerlin Gallery, Dublin
No Place (like home), Walker Art Center, Minneapolis (catalogue)
P.S.1 – Opening Project, Long Island City, New York
Re/View: Photographs from the Collection, Dallas Museum of Art, Texas
Shot – Reverse Shot, Walter Phillips Gallery, Banff
Surroundings, Tel Aviv Museum of Art, Tel Aviv (catalogue)
Ten Contemporary Photographers, Vaknin Schwartz, Atlanta, Georgia

1996 *Being and Time: The Emergence of Video Projection*, Albright–Knox Art Gallery, Buffalo; Portland Art Museum, Oregon; Contemporary Arts Museum, Texas; Cranbrook Art Museum, Michigan (1997) (catalogue)
Face à l'histoire 1933–1996, Centre Georges Pompidou, Paris (catalogue)
Happy End, Kunsthalle, Düsseldorf
ID, Stedelijk Van Abbemuseum, Eindhoven; Nouveau Musée/Institut, Villeurbanne (catalogue)
NowHere, Louisiana Museum of Modern Art, Humlebaek
The 10th Biennial of Sydney, Sydney
Language, Mapping and Power, Orchard Gallery, Derry (catalogue)
L'Imaginaire irlandais, École Nationale Superieure des Beaux-Arts de Paris, Paris
ACE! Arts Council Collection: New Purchases, Hatton Gallery, Newcastle upon Tyne; Oldham Gallery, Oldham; Hayward Gallery, London
Circumstantial Evidence: Terry Atkinson, Willie Doherty, John Goto, University of Brighton (catalogue)

1995 *Distant Relations: A Dialogue among Chicano, Irish and Mexican Artists*, Santa Monica Museum of Art, Los Angeles; Ikon Gallery, Birmingham; Museo de Arte Contemporaneo de Carrillo Gill, Mexico City; Camden Arts Centre, London; Irish Museum of Modern Art, Dublin (1996)
Amnesty International Exhibition, Kelvingrove Gallery, Glasgow; Camden Arts Centre, London; Irish Museum of Modern Art, Dublin (1996)
Landscape Fragments, Centre d'Art Contemporain de Vassiviere en Limousin
IMMA Collection: Photoworks, Irish Museum of Modern Art, Dublin
Sites of Being, The Institute of Contemporary Art, Boston
New Art in Britain, Muzeum Sztuki, Lodz (catalogue)
It's Not a Picture, Galleria Emi Fontana, Milan
Trust, Tramway, Glasgow
Festival 'Printemps de Cahors', France
Willie Doherty/Andreas Gursky, Moderna Museet, Stockholm
IMMA/Glen Dimplex Artists Award, Irish Museum of Modern Art, Dublin (brochure)
Double Play: Beyond Cognition, Saint-Niklaas City Academy, Belgium
Make Believe, Royal College of Art, London (catalogue)
Summer Exhibition, Kerlin Gallery, Dublin
Turner Prize 1994, Wilfe Doherty, Peter Doig, Antony Gormley, and Shirazeh Houshiary, Tate Gallery, London *(The Only Good One is a Dead One)* (catalogue)
Willie Doherty/Mona Hatoum/Doris Salcedo, Brooke Alexander, New York
From Beyond the Pale: Selected Works and Projects, Part 1, Irish Museum of Modern Art, Dublin
Cocido y Crudo, Museo Nacional Centro de Arte Reina Sofia, Madrid (catalogue)
Points of Interest, Points of Departure, John Berggruen Gallery, San Francisco
Kraji/Places, Moderna Galerija Ljubljana, Museum of Modern Art, Slovenia (catalogue)
The Act of Seeing (Urban Space), Fondation pour l'Architecture, Brussels
The Spine, De Appel, Amsterdam (catalogue)
1993 *Krieg (War)*, Neue Galerie, Graz (catalogue)
Critical Landscapes, Tokyo Metropolitan Museum of Photography, Tokyo (catalogue)
Prospect 93, Frankfurter Kunstverein, Frankfurt (catalogue)
An Irish Presence, Venice Biennale, Venice
1992 *Spielholle*, Grazer Kunstverein, Graz; Sylvana Laurenz Galerie, Paris; Bockenheimer/University Underground Station, Frankfurt
Twelve Stars, Arts Council Gallery, Belfast
Beyond Glory: Re-presenting Terrorism, College of Art, Maryland Institute, Baltimore
Moltiplici Culture, Convento di S. Egidio, Rome (catalogue)
"Outta Here", Transmission Gallery, Glasgow

13 Critics 26 Photographers, Centre d'Art Santa Monica, Barcelona (catalogue)
Time Bandits, Galleria Fac-Simile, Milan
1991 *Gallery Artists*, Oliver Dowling Gallery, Dublin
Denonciation, Usine Fromage, Darnetal, Normandy; Centre d'Art Santa Monica, Barcelona; Hamburg (catalogue)
Political Landscapes, Perspektief, Rotterdam
Outer Space, Laing Art Gallery, Newcastle upon Tyne and touring Hull, London, Bristol (catalogue)
A Place for Art ?, The Showroom, London
Europe Unknown, WKS Wawel, Krakow (catalogue)
Storie, Galleria il Campo, Rome; Galleria Casoli, Milan
Shocks to the System, Royal Festival Hall, London; Ikon, Birmingham (catalogue)
1990 *A New Tradition*, Douglas Hyde Gallery, Dublin (catalogue)
XI Photography Symposium Exhibition, Graz
The British Art Show, McLellan Galleries, Glasgow; Leeds City Art Gallery; Hayward Gallery, London (1990/1991) (catalogue)
1989 *Three Artists*, London Street, Derry
Gallery Artists, Oliver Dowling Gallery, Dublin
I International Foto-Triennale, Esslingen (catalogue)
Through the Looking Glass, Barbican Arts Centre, London (catalogue)
1988 *Gallery Artists*, Oliver Dowling Gallery, Dublin
Matter of Facts, Musée des Beaux Arts, Nantes; Musée d'Art Moderne, St. Etienne; Metz pour La Photographie, Metz (catalogue)
Three Artists, Battersea Arts Centre, London
1987 *Ireland/Germany Exchange*, Guinness Hop Store, Dublin; Ulster Museum, Belfast; Bonn; Würzburg (1988) (catalogue)
Critic's Choice, Limerick City Art Gallery
Gallery Artists, Oliver Dowling Gallery, Dublin
The State of the Nation, Herbert Art Gallery, Coventry
A Line of Country, Cornerhouse, Manchester (catalogue)
North West Artists Association, Heritage Library, Derry
Directions Out, Douglas Hyde Gallery, Dublin (catalogue)
1986 *Guinness Peat Aviation Exhibition*, Dublin (catalogue)
1985 *Points of View*, Heritage Library, Derry
1983 *Days and Nights: A Slidework*, Art and Research Exchange, Belfast
Guinness Peat Aviation Exhibition, Dublin (catalogue)
1982 *New Artists, New Works*, Project Arts Centre, Dublin; Orchard Gallery, Derry (catalogue published as *8 Weeks 8 Works* by Orchard Gallery Publications, Derry)
Photographic Collages, King Street Gallery, Bristol
Live Work, Crescent Art Centre, Belfast; Artspace, Cork (1983)
1981 *Irish Exhibition of Living Art*, Dublin
Work Made Live, National College of Art and Design, Dublin

PUBLIC PROJECTS

1995 *The Space Between,* video installation, El Puente de Vizcaya, Bilbao
 Make Believe, a poster project for British Rail mainline stations

1994 *Installation,* Washington Square Windows, Grey Art Gallery, New
 York

1993 *Burnt-Out Car,* street poster, An Irish Presence, Venice Biennale

1992 *It's Written All Over My Face,* billboard poster commissioned by the
 BBC Billboard Project as part of the Commissions and
 Collaborations season
 A Nation Once Again, street poster commissioned by Transmission
 Gallery, Glasgow, as part of *"Outta Here"*

1990 *False Dawn,* billboard project organized by *Irish Exhibition of
 Living Art,* Dublin

1988 *Art for the Dart,* a project on Dublin's suburban rail link, organized
 by the Douglas Hyde Gallery, Dublin
 Metro Billboard Project, Projects UK: billboard shown in Newcastle,
 Leeds, Manchester, Derry and London

BIBLIOGRAPHY
MONOGRAPHS AND EXHIBITION CATALOGUES

2002 *Willie Doherty: True Nature* (essay by Caoimhín Mac Giolla Léith).
 Chicago: The Renaissance Society
 Willie Doherty, Re-Run, 25 Bienal de São Paulo (essay by Charles
 Merewether), exhibition brochure. São Paulo: The British Council

2001 *Willie Doherty: How it Was* (essay by Daniel Jewesbury). Belfast:
 An Ormeau Baths Gallery Commission

2000 *Willie Doherty: Extracts From a File* (essays by Friedrich
 Meschede, Eva Schmidt, Hans-Joachim Neubauer). Berlin: DAAD

1999 *Willie Doherty: Dark Stains* (essays by Maite Lorés and Martin
 McLoone). Koldo Mitxelena Kulturunea, Donostia-San Sebastián

1998 *Somewhere Else* (essay by Ian Hunt). Liverpool: Tate Gallery,
 Liverpool in association with the Foundation for Art and Creative
 Technology (FACT)

1997 *Willie Doherty: Same Old Story* (essays by Martin McLoone and
 Jeffrey Kastner). London: Matt's Gallery

1996 *Willie Doherty* (essay by Olivier Zahm). Paris: Musée d'Art Moderne
 de la Ville de Paris
 Willie Doherty: In the Dark. Projected Works (essays by Carolyn
 Christov-Bakargiev and Ulrich Loock). Bern: Kunsthalle Bern
 Willie Doherty: The Only Good One is a Dead One (essay by Jean
 Fisher). Edmonton: Edmonton Art Gallery; Saskatoon: Mendel Art
 Gallery
 No Smoke without Fire (text by Willie Doherty). London: Matt's
 Gallery
 The Only Good One is a Dead One. Lisbon: Fundaçáo Calouste
 Gulbenkian

1994 *At the End of the Day* (essay by Carolyn Christov-Bakargiev),
 exhibition brochure. Rome: British School at Rome

1993 *Willie Doherty: Partial View* (essay by Dan Cameron). Dublin: The
 Douglas Hyde Gallery in association with the Grey Art Gallery and
 Study Center, New York University, and Matt's Gallery, London

1991 *Unknown Depths* (essay by Jean Fisher). Cardiff: Ffotogallery in
 association with Third Eye Centre, Glasgow, and Orchard Gallery,
 Derry

GROUP EXHIBITION CATALOGUES AND PUBLICATIONS

2002 Jewesbury, Daniel. *Países, 25 Bienal de São Paulo.* São Paulo

2001 Mac Namara, Aoife. *The Inner State: The Image of Man in the
 Video Art of the 1990s.* Vaduz: Kunstmuseum Liechtenstein
 Schlieker, Andrea. *Double Vision.* Leipzig: Galerie für
 Zeitgenössische Kunst; Berlin: DAAD; London: The British Council

2000 Païni, Dominique, Guy Cogeval. *Hitchcock and Art: Fatal
 Coincidences.* Montréal: The Montréal Museum of Fine Arts
 Arnold, Bruce, Declan McGonagle, Oliver Dowling, Medb Ruane,
 Dorothy Walker and Caoimhín Mac Giolla Léith. *Shifting Ground:
 Selected Works of Irish Art 1950–2000.* Dublin: Irish Museum
 of Modern Art
 Cullen, Fintan. *Sources in Irish Art: A Reader.* Cork: Cork
 University Press
 Look Out. catalogue accompanying a touring exhibition organized
 by Art Circuit
 Buck, Louisa. *Moving Targets 2: A User's Guide to British Art Now.*
 London: Tate Gallery Publishing

1999 Gallagher, Ann and Patrick Kellier. *Landscape.* London: The British
 Council
 McGonagle, Declan, Fintan O'Toole and Kim Levin. *Irish Art Now:
 From the Poetic to the Political.* London: Merrell Publishers;
 Dublin: IMMA
 Rush, Michael. *New Media in Late 20th Century Art.* London:
 Thames & Hudson
 War Zones. Vancouver: Presentation House Gallery
 Des conflits intérieurs. France: Le Point du Jour Editeur, Le Rozel,
 Normandy
 1999 Carnegie International. Pittsburgh: Carnegie Museum of Art

1998 *New Art from Britain.* Innsbruck: Kunstraum
 Godfrey, Tony. *Conceptual Art* (Art + Ideas series). London: Phaidon
 Press
 Real/Life: New British Art. Tochigi Prefectural Museum of Fine
 Arts; Fukoma City Art Museum; Hiroshima: Hiroshima City Museum
 of Contemporary Art; Tokyo: Museum of Contemporary Art; Ashiya
 City Museum of Art and History, Japan

1997 *Pictura Britannica, Art from Britain.* Sydney: Museum of
 Contemporary Art
 Città/Nattura. Rome: Palazzo delle Esposizioni
 Dimensions Variable. London: The British Council
 Islas. Canary Islands: Centro Atlantio de Arte Moderno
 Flood, Richard. *No Place (like home).* Minneapolis: Walker Art Center

166

Sela, Rona. *Surroundings*. Tel Aviv: Tel Aviv Museum of Art

Buck, Louisa. *Moving Targets: A User's Guide to British Art Now*, London: Tate Gallery Publishing

Button, Virginia. *The Turner Prize*. London: Tate Gallery Publishing

1996 Kelly, Liam. *Thinking Long: Contemporary Art in the North of Ireland*. Cork: Gandon Editions

Face à l'histoire 1933–1996. Paris: Centre Georges Pompidou

Mayer, Marc. *Being and Time: The Emergence of Video Projection*. Buffalo: Albright–Knox Art Gallery

Fisher, Jean. *ID*. Eindhoven: Stedelijk Van Abbemuseum

Green, David and Peter Seddon. *Circumstantial Evidence: Terry Atkinson, Willie Doherty, John Goto*. Brighton: University of Brighton

Kelly, Liam. *Language, Mapping and Power*. Derry: Orchard Gallery

1995 *IMMA/Glen Dimplex Artists' Award*. Dublin: Irish Museum of Modern Art

Make Believe. London: Royal College of Art

1994 *Turner Prize 1994*. London: Tate Gallery Publishing

Cocido y Crudo. Madrid: Museo Nacional Centro de Arte Reina Sofia

Strumej, Lara. *Kraji/Places*. Slovenia: Moderna Galerija Ljubljana – Museum of Modern Art

The Act of Seeing (Urban Space). Brussels: Fondation pour l'Architecture, Brussels

The Spine. Amsterdam: De Appel

1993 *Krieg (War)*. Graz: Edition Camera Austria

Prospect 93. Frankfurt: Frankfurter Kunstverein

Critical Landscapes. Tokyo: Tokyo Metropolitan Museum of Photography

La Biennale di Venezia. Venice: XLV Esposizione Internazionale d'Arte

1992 *La Recherche Photographique*. Paris: 13

Molteplici Culture. Rome: Edizioni Carte Segrete

13 Critics 26 Photographers. Barcelona: Centre d'Art Santa Monica

Perspektief 43. Rotterdam: Perspektief

1991 *Outer Space*. London: South Bank Centre

Denonciation, La Difference. France: GNAC

Camera Austria 37. Graz, Austria

Inheritance and Transformation. Dublin: Irish Museum of Modern Art

Kunst Europa. Germany: AdKV

Europe Unknown. Poland: Ministry of Culture

Shocks to the System. London: South Bank Centre

1990 *A New Tradition*. Dublin: Douglas Hyde Gallery

The British Art Show. London: South Bank Centre

1989 *I International Foto-Triennale*. Esslingen

Through the Looking Glass. London: Barbican Art Gallery

1988 *Matter of Facts*. Nantes: Musée des Beaux Arts; St. Etienne: Musée d'Art Moderne; Metz: Metz pour La Photographie

An Interview. Dublin: Olver Dowling Gallery

1987 *Ireland/Germany Exchange*. Dublin: Goethe-Institut, Arts Council of Ireland

A Line of Country. Manchester: Cornerhouse

Directions Out. Dublin: Douglas Hyde Gallery

1986 *Guinness Peat Aviation Exhibition*. Dublin

1982 *8 Weeks 8 Works*. Derry: Orchard Gallery

Irish Exhibition of Living Art. Dublin

1980 *Artwork*. Derry: Orchard Gallery Publications

SELECTED PUBLIC COLLECTIONS

Albright–Knox Art Gallery, Buffalo

Arts Council of Ireland, Dublin

Arts Council Collection, London

Cork Municipal Art Gallery, Cork

Dallas Museum of Art, Texas

Fonds National d'Art Contemporain, Paris

FRAC, Champagne, Ardennes

Irish Museum of Modern Art, Dublin

Moderna Museet, Stockholm

NYC School of Social Research, New York

Royal Armouries Collection, Leeds

Sammlung Goetz, Munich

Simmons & Simmons Collection, London

Solomon R. Guggenheim Museum, New York

Tate Gallery, London

The British Council, London

The Carnegie Museum, Pittsburgh

The European Commission/Parliament, Brussels

The Imperial War Museum, London

University of Ulster, Belfast

Vancouver Art Gallery, Vancouver

Vivendi Collection, Paris

Weltkunst Foundation, London

Wolverhampton Art Gallery, Wolverhampton

ACKNOWLEDGEMENTS

The Irish Museum of Modern Art is grateful to private collectors and public collections who generously lent their works for the exhibition. In particular, we would like to thank the Contemporary Irish Arts Society/Irish Hospice Foundation and the Goetz Collection, Munich. The Museum and Merrell Publishers would like to thank Willie Doherty, Robin Klassnik and writers Caoimhín Mac Giolla Léith and Carolyn Christov-Bakargiev. The Museum would also like to thank Declan McGonagle and Annie Fletcher for their support, and Alexander and Bonin, New York, Matt's Gallery, London, and Kerlin Gallery, Dublin, for their involvement and assistance.

The artist would like to thank Brenda McParland for initiating this project and for her unfailing commitment; her colleagues Alexa Coyne, Karen Sweeney and Rachael Thomas at the Irish Museum of Modern Art for their professionalism and good humour; Mark Stevens and Deirdre Courtney; and Declan McGonagle and Annie Fletcher for their work on the early stages of the project. The artist is always grateful to the following long-standing collaborators: Peter Kilchmann, Emi Fontana, Jennifer Flay, John Kennedy and David Fitzgerald. Thanks to Oliver Dowling for my first solo exhibition; to Carolyn Alexander and Ted Bonin for their care and dedicated professionalism; and to Robin and Kathryn Klassnik for their hospitality, friendship and advice. The artist would also like to thank Hugh Merrell and all the staff at Merrell Publishers, and the designer Karen Wilks, for their dedication to making this book a reality. Thanks also to Carolyn Christov-Bakargiev and Caoimhín Mac Giolla Léith for their insights and intellectual engagement with the work. The artist acknowledges the support of the staff and students of the School of Art and Design, University of Ulster. Finally, this book is dedicated to Angela and Joanna, Tomas, Eabha and Michael; it wouldn't be possible without you.

Photographic acknowledgements and credits

The Museum and the publisher wish to express their thanks to all those who provided photographic material and/or permission to reproduce material, including:

Alexander and Bonin, New York, photography by D. James Dee, New York, and Orcutt & Van Der Putten, New York; Matt's Gallery, London, photography by Mimmo Capone, John Riddy, Edward Woodman; Renaissance Society, Chicago, photography by Tom van Eynde; Galerie Peter Kilchmann, Zurich, photography by A. Burger; Koldo Mitxelena Kulturunea, Donostia-San Sebastián, photography by Alberto Martinena; Angles Gallery, Santa Monica, California, photography by Brian Forest; Irish Museum of Modern Art, Dublin, photography by Denis Mortell.

Images © Willie Doherty with the exception of: page 35: image copyright PA Photos, text courtesy of *Daily Mirror*; page 16 (top): Andrea Mantegna (1431–1506), *The Dead Christ*, *c.* 1480–90, oil on canvas, Pinacoteca di Brera, Milan, Italy/Bridgeman Art Library, under licence from the Italian Ministry for Cultural Goods and Activities; pages 19, 36, 156 (top right): source for still image courtesy RTE Archive Library; pages 23, 156 (top left): image copyright PA Photos.